IMAGES
of America

HISTORIC
SILVER SPRING

SILVER SPRING DOCUMENTARY FILM POSTCARD. This postcard was published by Public Broadcasting Service (PBS) affiliate WETA TV 26 for the December 8, 2002, debut broadcast of *Silver Spring: Story of an American Suburb*. The documentary film was produced and directed by longtime Silver Spring resident Walter J. Gottlieb and his production company, Final Cut Productions, in partnership with the Silver Spring Historical Society. The 90-minute documentary takes viewers on a 160-year trip through the history of one of Washington, D.C.'s oldest and most fascinating suburbs, Silver Spring, Maryland. The film follows Silver Spring's history from the fateful horseback ride that led to Silver Spring's founding in 1840 to the community's boom time as a bustling retail center in the 1940s and 1950's to its eventual decline and ultimate rebirth. For ordering information contact Final Cut Productions, (301) 585-2800, e-mail FinalCutTV@aol.com or visit www.silverspringfilm.org. (SSHS.)

ON THE COVER. The Montgomery Blair High School Marching Band participates in a November 11, 1966, Veterans' Day ceremony in front of the Silver Spring, Maryland, National Guard Armory. The U.S. Army photograph is by C. M. Crawford. (CS.)

IMAGES
of America

HISTORIC
SILVER SPRING

Jerry A. McCoy and the
Silver Spring Historical Society

ARCADIA
PUBLISHING

Published by Arcadia Publishing
Charleston, South Carolina

Printed in the United States of America

Library of Congress Catalog Card Number: 2005928191

For all general information contact Arcadia Publishing at:
Telephone 843-853-2070
Fax 843-853-0044
E-mail sales@arcadiapublishing.com
For customer service and orders:
Toll-Free 1-888-313-2665

Visit us on the Internet at www.arcadiapublishing.com

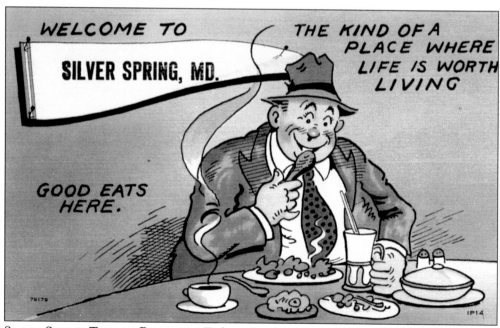

SILVER SPRING TOURIST POSTCARD. Tichnor Brothers, Inc., of Boston, published this 1940s "Tichnor Quality View" postcard. A generic design, the postcard featured a blank pennant upon which a community's name could be overprinted. (JAM.)

CONTENTS

ACKNOWLEDGMENTS

This book is dedicated to my wife, Nan, whose decision in 1992 to buy a house in downtown Silver Spring and subsequent patience over the ensuing years has enabled me to pursue my passion for documenting and preserving our community's fascinating past.

The Silver Spring Historical Society is indebted to all who have shared with us their photographs, allowing the society to pursue its mission to "create and promote awareness and appreciation of Silver Spring's heritage through sponsorship of educational activities and the preservation and protection of historical sites, structures, artifacts and archives."

At the end of each caption is an abbreviation indicating the source of the image.

AR Ara Mesrobian, Chevy Chase, Maryland
BI Barwood Inc., Kensington, Maryland
BMF Betty Main Fowler, Selbyville, Delaware
BS Bullis School, Potomac, Maryland
BWF Beverly Wright Fincham, Silver Spring
CFM Charles F. Marston, Adelphi, Maryland
CS Cissel-Saxon Post No. 41, The American Legion, Silver Spring
CSW Christine Stokely Williard, Silver Spring
CTS Charles T. Schrider Jr., Silver Spring
DBO Daniel B. O'Brien, Bryanstown, Maryland
DCPL District of Columbia Public Library, Martin Luther King Jr. Memorial Library, Washingtoniana Division, Washington, D.C.
DS Dave Stovall, Rockville, Maryland
EBL E. Brooke Lee III, Lee Development Group, Inc., Silver Spring
EPJ Edna Paul Jennings, Atlanta
ER Eunice Ramsey, Silver Spring
GJ Guy Jones, Mill Creek, Washington
GL Gary Levy, Olney, Maryland
GS Gene Slatick, Silver Spring
HAER Historic American Engineering Record, Library of Congress, Washington, D.C.
HDS Helen Dolan Sherbert, Silver Spring
HL Huntington Library, San Marino, California
HSW Historical Society of Washington, Washington, D.C.
JAM Jerry A. McCoy, Silver Spring
JCP J. C. Penney Museum and Archives, Dallas
JCR Joseph C. Reynolds, Silver Spring
JJV Joseph J. Valachovic, Glen Burnie, Maryland
JPH John "Jack" P. Hewitt, Silver Spring
JRH John R. Hiltz Arlington, Virginia
KL Ken Lubell, Tires of Silver Spring, Silver Spring

LOC Library of Congress, Prints and Photographs, Washington, D.C.
MAG Margaret A. Gleason, Silver Spring
MBHS Montgomery Blair High School, Silver Spring
MCHS Montgomery County Historical Society, Rockville, Maryland
MD Maryland Department, Enoch Pratt Free Library, Baltimore
MIT MIT Press, Cambridge, Massachusetts
MWJC Mitchell Wolfson Jr. Collection, Wolfsonian-Florida International University, Miami Beach
NA National Archives, Washington, D.C.
PA Peggy Appleman, Falls Church, Virginia
PR Peerless Rockville, Rockville, Maryland
RB Robert Burdette, Sandy Springs, Maryland
RBP Ronald B. Pease, Silver Spring
RJSG Diner Archives of Richard J. S. Gutman, West Roxbury, Massachusetts
RKN Richard K. Neumann, Phoenix, Arizona
SL Sandy Lutes, Silver Spring
SN Susan Neal, Liberty, South Carolina
SPG Shirley Packett Gable, Silver Spring
SSHS Silver Spring Historical Society, Silver Spring
SSL Silver Spring Library, Silver Spring
SSPO Silver Spring Post Office, Silver Spring
SSWC Silver Spring Women's Club, Silver Spring
TLU Thomas L. Underwood Jr., Arlington, Virginia
WP Wes Ponder, Rockville, Maryland

INTRODUCTION

In the February 1975 issue of *Preservation News*, a periodical of the National Trust for Historic Preservation, television broadcast journalist David Brinkley said about our community, "There's a suburb of Washington named Silver Spring, MD, and it is perfectly hideous—rampant, unplanned, uncontrolled post war growth. It's horrible. There's a Chevrolet dealer's building on one of its main corners, called Loving Chevrolet. They have a commercial on the radio with a little jingle that goes: 'The prettiest thing in Silver Spring is Loving Chevrolet.' The sad part is, it's true."

I would like to think that Brinkley had overlooked the many historic as well as unique buildings that gave downtown Silver Spring its character. The crossroads of Georgia Avenue and Colesville Road, our main streets, features the restored, historic 1938 Silver Theatre and Shopping Center. However, the surrounding cityscape of gleaming high-rise office and residential buildings that continue to be developed are being done so through the sacrifice of our earlier, human-scaled Silver Spring. Many structures that contributed to our community's sense of place have been razed to accommodate this expanding, homogenized landscape. Historic preservationists have had to fight for the retention of many of Silver Spring's important landmarks. That fight to protect and preserve our community's history will continue.

Silver Spring founder Francis Preston Blair probably never imagined what his discovery would evolve into. Blair was a newspaper editor from Frankfort, Kentucky, who came to Washington, D.C., in 1830 at the behest of Pres. Andrew Jackson to edit the *Washington Globe*. Blair had taken up residency in what is known today as Blair House, since 1942 the official guesthouse of the president of the United States. Desiring to escape the "miasma" of summers in Washington, Blair decided to construct a country house.

In 1955, Blair Lee III, the great-great-grandson of Francis Preston Blair, told the story of how Silver Spring was founded. Blair went horseback riding along the Seventh Street Pike (Georgia Avenue) with his daughter, Elizabeth, in 1840. Elizabeth, Blair's only daughter, was astride a horse named Selim and reading a love letter from a young naval lieutenant named Samuel Phillips Lee, whom she later married. Not paying attention, Elizabeth was brushed off her mount by a tree limb. Selim took off, and when finally located by father and daughter, was discovered to be drinking from a small spring. In the spring's water was mica sand, and when the sun reflected off the water it sparkled like silver. Papa Blair looked around, liked what he saw, and decided he had found the site for his home, which he would name Silver Spring.

So ensconced is this version in the Lee family history that a silhouette of the event's discovery forms the logo of their company. If you walk into Lee Plaza, located at the corner of Georgia Avenue and Colesville Road, you will see the logo set into the lobby floor. Blair and Elizabeth are standing beside Selim, lapping water from the spring, and all are standing near the sheltering boughs of an oak tree.

Every story has two sides, and so, it appears, does this one. The Blair family had a slightly different version of the spring's discovery. On April 17, 1917, Gist Blair, grandson of Francis Preston Blair, presented a paper before the Columbia Historical Society titled "Annals of Silver Spring." "While riding Selim one day outside the boundary of the district of Columbia, his [Francis Preston Blair's] horse became frightened and threw his rider and ran away among the thick growth of pines in the valley to the west of the road [Georgia Avenue]. He followed his horse into the woods and found him snared by the reins by a bush which had caught the reins dangling, and near the place was a beautiful spring full of white sand and mica which the gush of water from the earth forced into a small column which sparkled as it rose and fell like silver. He was charmed by the spot and purchased the property."

So, was Elizabeth Blair Lee actually there? Perhaps we will never know, but I think credit should be given to the true founder of Silver Spring, Selim! Other than Selim Road, which

parallels the north side of the CSX/Metro tracks bounded by Burlington Avenue to the east and the intersection of Philadelphia Avenue and Georgia Avenue to the west, one would be hard pressed to find any other acknowledgement of our founding horse in downtown Silver Spring. Located on Selim Road is collection of c. 1940 industrial buildings with a small county-owned parking lot at the west end. Perhaps the parking lot could be converted into a park and a statue of Selim erected!

Many more fascinating aspects of our community's history await you in the pages of *Historic Silver Spring*. The Silver Spring Historical Society hopes that you enjoy this collection of archival images with a few contemporary ones thrown in. If you can help identify any of the many unidentified individuals pictured in this book, please contact us. We also welcome any additional information on the many persons, places, buildings, and items depicted. An addendum may be found on our Web site that features a bibliography and index to this work. Thank you for helping the Silver Spring Historical Society preserve Silver Spring's history!

Jerry A. McCoy
President
Silver Spring Historical Society
PO Box 1160
Silver Spring, MD 20910-1160
sshistory@yahoo.com
www.sshistory.org

One

THROUGH THE LENS OF WILLARD R. ROSS
Silver Spring in 1917 and 1928

For two decades commencing in 1910, Washington, D.C., photographer Willard R. Ross (1860–1948) published nearly 2,000 individual postcards depicting hometown Washington, D.C. These views included businesses, churches, schools, private residences, historic structures, street scenes, civic events, and people. Ross occasionally ventured into neighboring Maryland and Virginia to photograph new views in order to expand his postcard stock. On Thursday, June 21, 1917, Ross visited the flourishing community of Silver Spring.

Ross probably rode a couple of streetcars from his home at 39 Q Street NE. Arriving at the end of the line near the present Georgia and Alaska Avenues, he gathered his view camera, tripod, and glass-plate negatives and walked the short distance to the community's namesake, the Silver Spring. Heading north on the Washington and Brookeville Turnpike (today's Georgia Avenue), Ross photographed Silver Spring's major businesses and landmarks. Ross finished his day by photographing the community's school, located in the Woodside neighborhood.

Each of Ross's postcard views was numbered, with the highest number known being 20. Of the first 13 postcard views presented here, numbers on three of them are unknown. Three additional postcards not published in this volume are "B. and O. R. R. Station, Silver Spring, MD.—5," "Sligo Ave., Silver Spring, MD.—10" And "Silver Spring—20," which offer slightly different views than the ones presented here. Four more 1917 postcard views of Silver Spring thus remain to be discovered.

Nearly 11 years later, Ross returned to Silver Spring on Wednesday, March 28, 1928, to photograph new postcard views. The last seven postcard views in this chapter were taken on that day. These postcards (except one) have a number followed by an X, with the highest number known being 28. Twenty-one more 1928-postcard views of Silver Spring possibly remain to be discovered. The 1917 and 1928 postcard views are arranged in the order that Ross may have photographed them on his journey up Georgia Avenue over three quarters of a century ago.

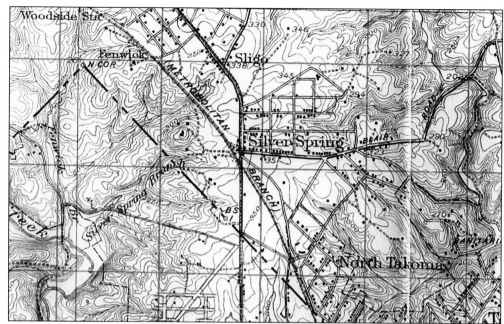

DETAIL OF 1917 "WASHINGTON AND VICINITY" MAP. The U.S. Geological Survey published this topographical "automobile edition" map. Brookeville Avenue, or Washington and Brookeville Turnpike as it was also known, runs north out of the District of Columbia into Silver Spring and on to Sligo, today's intersection of Georgia Avenue and Colesville Road. Black squares indicate footprints of structures as they existed during Ross's 1917 visit. (DCPL.)

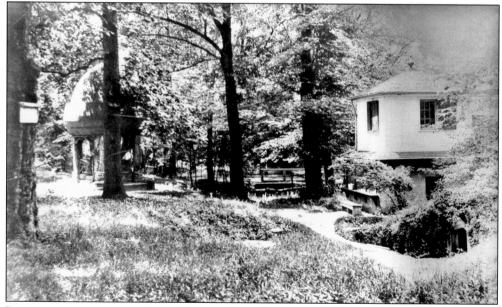

LANDSCAPE AROUND THE SILVER SPRING, ROSS POSTCARD 18. Surrounded by oak trees is the 1850s gazebo constructed in the shape of an acorn (left) and the spring opening (right). Next to the spring is a dairy house, which no longer exists. The original Silver Spring is the centerpiece of Acorn Park, located at the intersection of East-West Highway and Newell Street. The park is a Montgomery County–designated historic site. (JAM.)

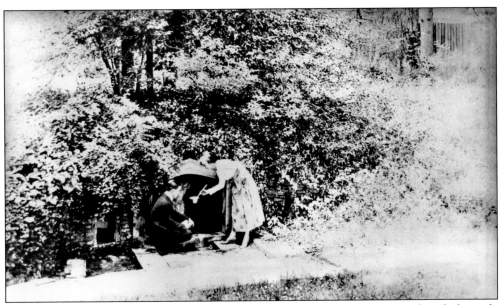

PARTAKING A SIP FROM THE SILVER SPRING, ROSS POSTCARD 11. This unidentified couple samples the spring water, which stopped flowing in the 1930s. Today circulating tap water supplied by the Washington Suburban Sanitary Commission offers visitors a semblance of a flowing spring. The Maryland–National Capital Park and Planning Commission has owned the spring site since 1942. The .12-acre urban park is all that remains of Francis Preston Blair's country estate, Silver Spring. (JAM.)

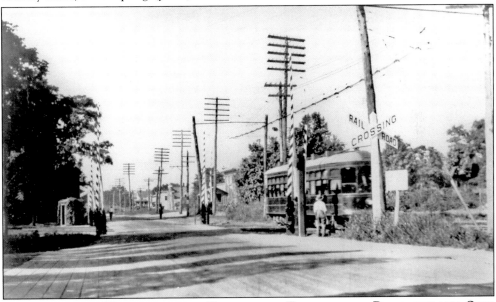

INTERSECTION OF WASHINGTON AND BROOKEVILLE TURNPIKE AND BALTIMORE AND OHIO RAILROAD. A Washington, Woodside, and Forest Glen Railway streetcar travels south on the Washington and Brookeville Turnpike, crossing the Baltimore and Ohio (B&O) Railroad tracks at grade. The railway line ran three miles from Eastern Avenue at the District of Columbia line to Forest Glen, Maryland, and operated from 1897 to 1924. The number of this Ross postcard is unknown. (JAM.)

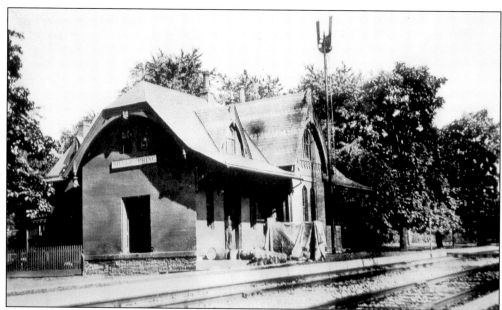

SILVER SPRING'S 1878 BALTIMORE AND OHIO RAILROAD STATION. Baltimore architect Ephraim Francis Baldwin designed this Ruskinian Gothic railroad station, the first stop in Maryland on the B&O's Metropolitan Branch. Opened in 1873, the branch ran from Washington, D.C., to Point of Rocks, Maryland, a distance of 42.5 miles. The structure was razed in 1945 for construction of a new station. The number of this Ross postcard is unknown. (JAM.)

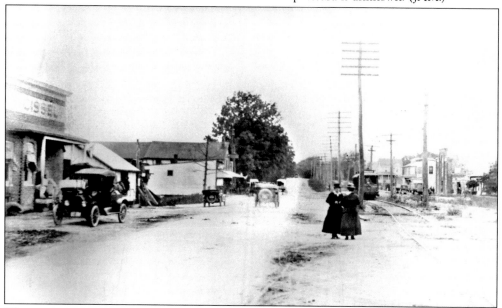

WASHINGTON AND BROOKEVILLE TURNPIKE LOOKING NORTH FROM SLIGO AVENUE, ROSS POSTCARD 7. Mrs. Charles Warren and Mrs. Rudolph Bender stand in the middle of the Washington and Brookeville Turnpike awaiting southbound Washington, Woodside, and Forest Glen Railway streetcar No. 1659. Note the B&O Railroad siding crossing the streetcar tracks. The siding extended from behind James H. Cissel's store (left) to Cissel's flour and feed buildings on the east side of the turnpike. (JAM.)

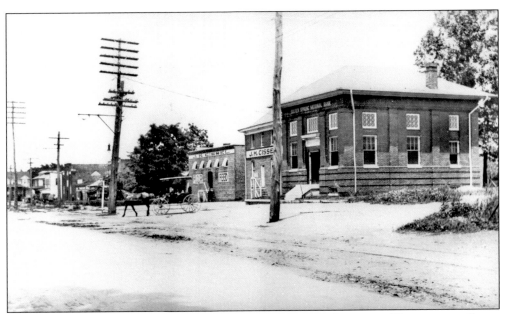

EAST SIDE OF WASHINGTON AND BROOKEVILLE TURNPIKE LOOKING NORTH FROM SLIGO AVENUE. A horse-drawn surrey approaches the turnpike on Sligo Avenue, separating James H. Cissel's flour and feed buildings and the Silver Spring National Bank. The bank, Silver Spring's first, opened October 10, 1910, at a cost of $4,984 ($102,000 in 2005 dollars). Cissel cofounded the bank and served as its longtime president commencing in 1910. The number of this Ross postcard is unknown. (JAM.)

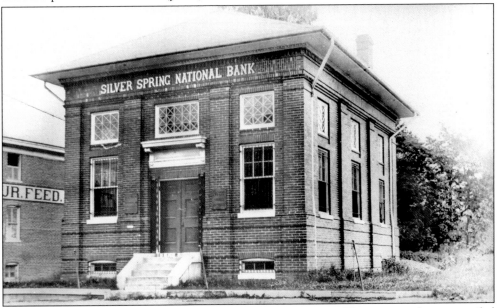

SILVER SPRING NATIONAL BANK, ROSS POSTCARD 3. This postcard was mailed November 17, 1920, from Mary to Miss Cora M. Crump, 86 Bowery Street, Frostburg, Maryland. Mary wrote, "On the reverse side you will find my new place of employment and believe me it is heaven compared to the other places I have had. Like it fine, then too it is close enough to home, so I have no carfare home to lunch, etc." (SSL.)

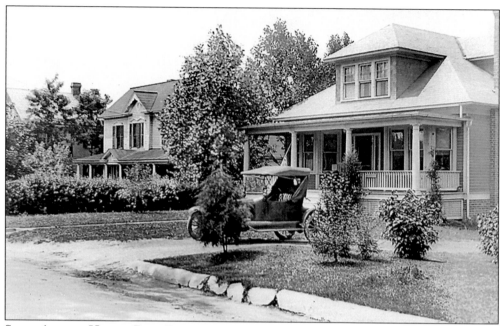

SLIGO AVENUE HOMES, ROSS POSTCARD 2. These homes were probably located on the north side of the 800 block of Sligo Avenue. They were typical of residences constructed in the Silver Spring Park subdivision, located on the east side of the Washington and Brookeville Turnpike across from the B&O Railroad station. (GJ.)

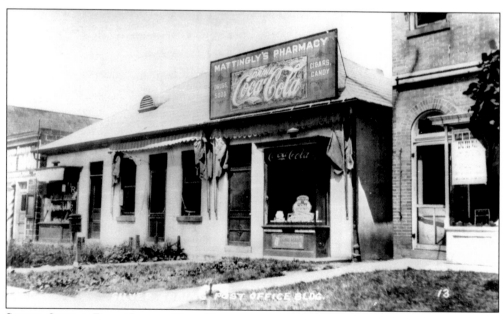

SILVER SPRING POST OFFICE, ROSS POSTCARD 13. Established on May 5, 1899, near the B&O Railroad station, by 1917 the Silver Spring Post Office was housed in the center portion of this building, left of Mattingly's Pharmacy. Security bars cover the post office's windows, and a mailbox on a post stands aside the sidewalk leading to the street. The structure, whose façade was altered in 1957, is located at 8123–8127 Georgia Avenue. (JAM.)

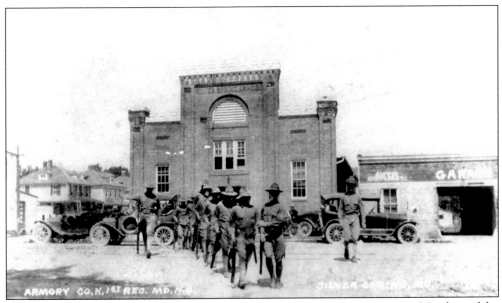

SILVER SPRING ARMORY, COMPANY K, 115TH INFANTRY, ROSS POSTCARD 12. Members of the Maryland National Guard's Company K perform military drills in the middle of the Washington and Brookeville Turnpike. Established by E. Brooke Lee and Frank L. Hewitt, the Silver Spring Armory was erected in 1914. In 1927, a new armory was constructed at 925 Wayne Avenue. It was razed in 1998. (JAM.)

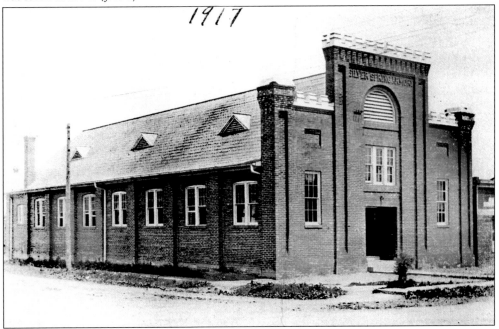

SILVER SPRING ARMORY, ROSS POSTCARD 6. In 1918, the State of Maryland sold the armory to the Silver Spring Fire Department for $5,500. Organized on May 15, 1915, the fire department shared the armory with Company K until 1927, when the latter relocated. Silver Spring Volunteer Fire Department Engine No. 1 occupied 8131 Georgia Avenue until 2006, when it relocated to a new station at 8110 Georgia Avenue. (SSHS.)

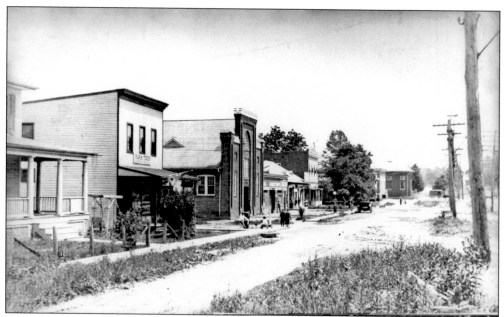

EAST SIDE OF WASHINGTON AND BROOKEVILLE TURNPIKE LOOKING SOUTH FROM SILVER SPRING AVENUE, ROSS POSTCARD 1. From left to right is the residence of Hugh F. O'Donnell (8209 Georgia Avenue) and his next-door commercial neighbor (8201 Georgia Avenue), whose sign above the porch awning reads, "Ajax Tires Guaranteed 5000 Miles." The Washington, Woodside, and Forest Glen Railway streetcar tracks are just to the right of the telephone poles. (SSHS.)

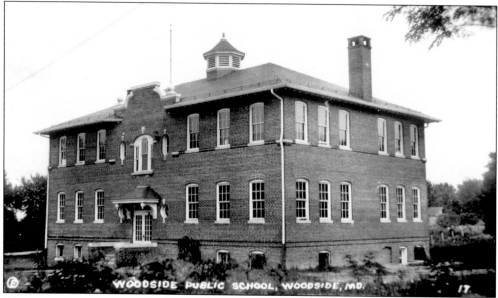

WOODSIDE SCHOOL, ROSS POSTCARD 17. Located on the southwest corner of Georgia Avenue and Ballard Street, this was the first consolidated elementary school in Silver Spring and one of the first structures on the west side of Georgia Avenue to be built with electrical wiring and light fixtures. It opened in 1909 and closed in 1982. The Silver Spring Health and Human Services Center is now located on the site. (JAM.)

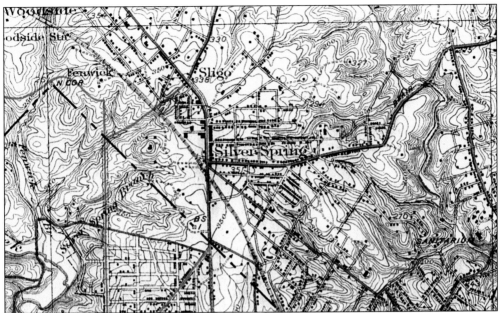

DETAIL OF 1929 "WASHINGTON AND VICINITY" MAP. This U.S. Geological Survey map shows the growth of Silver Spring since Ross's 1917 visit. Montgomery Avenue (today's Wayne Avenue) had been developed, as had E. Brooke Lee's first and second addition (west of Georgia Avenue and south of the yet-to-be extended Colesville Road), Blair Sections 1 and 2, and Blair-Takoma Section 1 (east of Georgia Avenue and south of Sligo Avenue). (DCPL.)

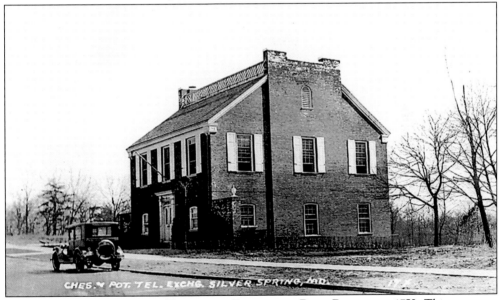

CHESAPEAKE AND POTOMAC TELEPHONE EXCHANGE, ROSS POSTCARD 17X. This structure was located on the south side of the Burlington Avenue section of East-West Highway (Maryland State Highway 410) between Georgia Avenue and Fenton Street. In 1889, Silver Spring obtained telephone service as part of the expansion of the Washington, D.C., network into the nearby Maryland suburbs. By 1928, Silver Spring had two telephone exchanges, Shepherd and Silver Spring. (GJ.)

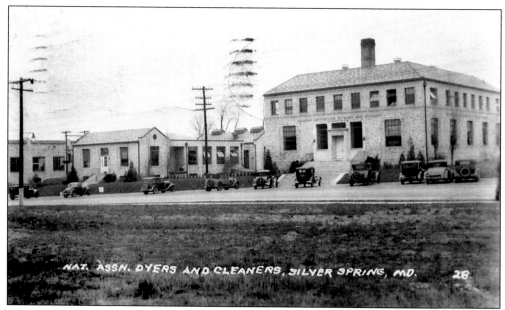

NATIONAL ASSOCIATION OF DYERS AND CLEANERS (NADC), ROSS POSTCARD 28. The NADC campus opened on October 17, 1927, with an eight-week-long course to promote research, training, and business interests of the dyeing and dry cleaning profession. This card was mailed from Silver Spring on January 26, 1931, by "Loy," who wrote, "These are the two bldg.s we had our class picture taken [sic] isn't so bad." (WP.)

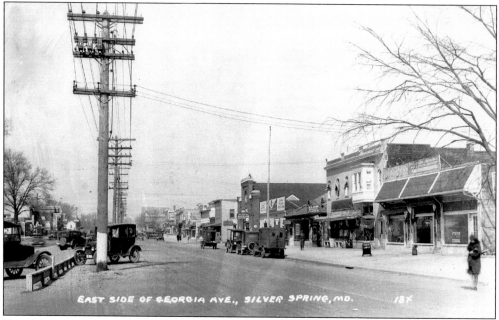

EAST SIDE OF GEORGIA AVENUE LOOKING NORTH FROM SLIGO AVENUE, ROSS POSTCARD 13X. With the demise of the streetcar line in 1924, the center portion of Georgia Avenue, formerly occupied by tracks, was utilized as angled automobile parking. The sign above the center business in the building on the right reads, "Silver Spring Pastry Shop," and above the display window is a sign for Sucrow's Sandwiches, run by Annie J. and Richard C. Sucrow. (WP.)

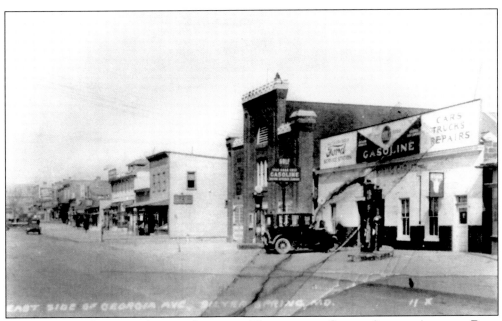

East Side of Georgia Avenue Looking North from Silver Spring Avenue, Ross Postcard 11X. The Washington and Brookeville Turnpike was now called Georgia Avenue and was paved. The Gulf gasoline station (right) at 8129 Georgia Avenue had grown from one pump to three. Over seven decades later, this address still services automobiles. (SSHS.)

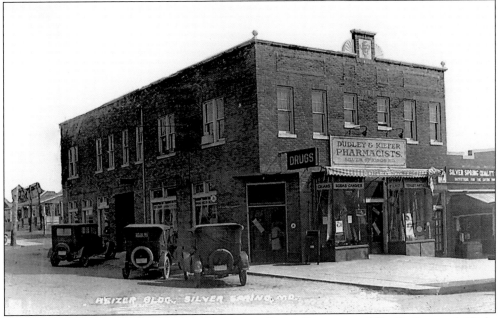

Heizer Building, 8241 Georgia Avenue, Ross Postcard 2X. Dudley and Kiefer Pharmacists, run by Frederick E. Dudley Jr. and Ralph S. Keifer, occupied the ground floor of this building, constructed by Roy M. Heizer c. 1927. Their sign above the canopy reads "Silver Springs, MD." At the top center of the building is an architectural carving of a satyr. A version of this carving can be seen today on the façade of 965–969 Thayer Avenue. (SSL.)

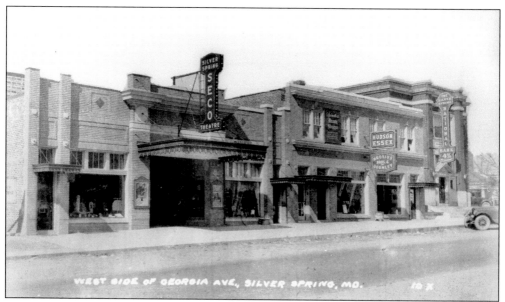

WEST SIDE OF GEORGIA AVENUE AT THAYER AVENUE, ROSS POSTCARD 10X. Silver Spring's first movie theater was the SECO (Suburban Electrical Company), opened on November 7, 1927, at 8242–8244 Georgia Avenue. Being screened the day Ross visited was the silent film *London After Midnight*, starring "The Man of a Thousand Faces," Lon Chaney. This film is one of the American Film Institute's nine most-wanted lost films. (JAM.)

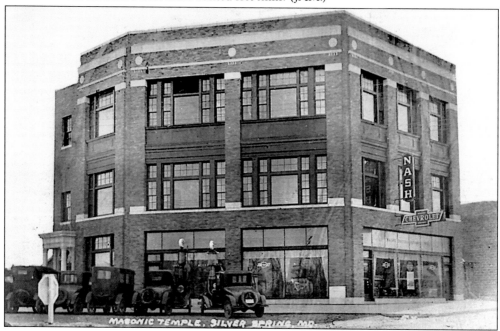

MASONIC TEMPLE, 8435 GEORGIA AVENUE, ROSS POSTCARD 5X. Constructed in 1927, the Masonic Temple was the tallest building in downtown Silver Spring when completed. The ground floor originally housed a Chevrolet and Nash automobile showroom, and the Silver Spring Masonic Lodge No. 215 occupied the upper floors. The building featured a cornerstone, now buried under a 1999 façade renovation. (GJ.)

Two

FROM COUNTRY ESTATES
TO LIGHT INDUSTRY
TO URBAN TOWERS
South Silver Spring

South Silver Spring holds the distinction of being the "birthplace" of our community. Here was located the spring discovered in 1840 by Francis Preston Blair, who subsequently purchased over 1,000 forested acres and built his country estate, Silver Spring. By 1890, Blair's descendants still owned most of the land located south of the present CSX/Metro railroad tracks extending from about Kalmia Road NW in the District of Columbia north to about Spring Street in Silver Spring.

Within 15 years of Blair's discovery, his sons, Montgomery and James, constructed their estates, Falkland and the Moorings, nearby. Over the next 100 years, these bucolic residences slowly became engulfed by the explosive urbanization of downtown Silver Spring, resulting in the razing of all but the Moorings by the mid-20th century. Commercial growth in South Silver Spring was at its peak at the end of World War II with the establishment of light industry along the East-West Highway corridor. Bottling plants, machine shops, printing plants, research labs, and multiple automobile service shops and dealers clustered here.

This industrial veneer and proximity to the District of Columbia resulted by the 1970s in the area around Georgia and Eastern Avenues being deemed less than desirable for residential purposes. The vacant 14-story Gramax Building symbolized for over a decade the perceived economic stagnation of the area. Like the quixotic plan to land helicopters on its rooftop, the long-desired revitalization of South Silver Spring was thought to be unattainable.

With the 21st century came the unprecedented economic revitalization of downtown Silver Spring. The first area to experience the trickle-down effect of revitalization was South Silver Spring. Due to South Silver Spring's close proximity to Washington, D.C., jobs and public transportation, as well as the "new" Downtown Silver Spring, a virtual explosion of condominium and apartment construction was underway by 2005, with nearly 2,000 units planned. The successful adaptive reuse of the 1945 Canada Dry Bottling Plant into condominiums will serve as a reminder of South Silver Spring's recent industrial past.

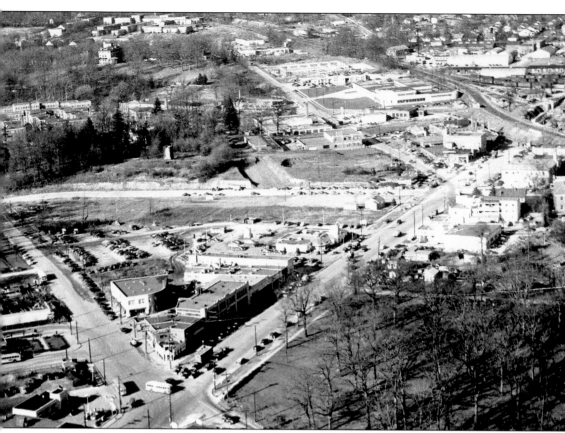

AERIAL VIEW OF SOUTH SILVER SPRING LOOKING NORTHEAST, C. 1947–1948. The two intersecting avenues forming a V are Eastern Avenue NW on the left (the border between the District of Columbia and Maryland), and Georgia Avenue on the right. Connecting the two is Thirteenth Street, skirting the partially wooded remains of Francis Preston Blair's 1842 estate, Silver Spring (barely visible in the trees). Prominently sited atop a tree-covered hill in the distance is *Falkland*, the estate constructed in 1854 by Blair's son, Montgomery. Spring Garden and Spring Knolls apartments sit between the two estates. Heavily wooded Jesup Blair Park lies at the bottom right. North of the park is the B&O's Metropolitan Branch tracks, temporarily rerouted for construction of the second Georgia Avenue underpass that opened on September 11, 1948. (SSHS.)

FRANCIS PRESTON BLAIR (1791–1876) AND HIS WIFE, ELIZA VIOLET HOWARD GIST (1794–1877). This is a reproduction of a photograph said to have been taken at Silver Spring, c. 1865. The Blairs married in 1812 and had four children: Montgomery (1813), Elizabeth (1818), James (1819), and Francis Jr. (1821). Mr. and Mrs. Blair are buried in Rock Creek Cemetery in Washington, D.C. Elizabeth is buried in Arlington National Cemetery with her husband, Samuel Phillips Lee. (LOC.)

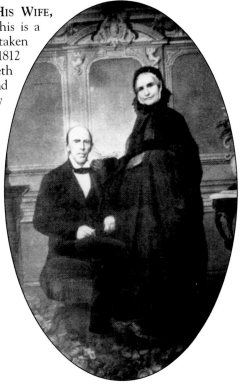

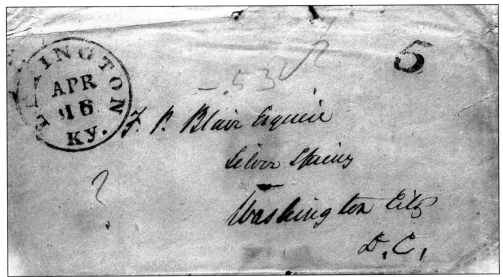

AN 1840S ENVELOPE MAILED TO FRANCIS PRESTON BLAIR. Addressed to Blair at "Silver Spring, Washington City, D.C.," this envelope was cancelled in Lexington, Kentucky, on April 16, c. 1845–1847, with a hand-stamped "5" indicating that the sender paid 5¢. During this time, postmasters issued their own hand stamps or adhesives. Philatelists refer to these as Postmasters' Provisionals. (JAM.)

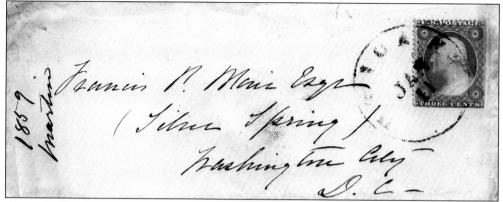

An 1850s Envelope Mailed to Francis Preston Blair. In early July 1847, the government issued its first adhesive postage stamps. This envelope was mailed from an illegible city on January 11 of (probably) 1859 from "Martin." The 3¢ George Washington stamp was issued in 1857. (JAM.)

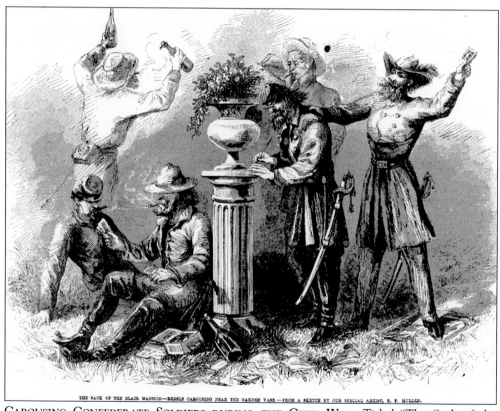

Carousing Confederate Soldiers during the Civil War. Titled "The Sack of the Blair Mansion—Rebels carousing near the garden vase.—From a sketch by our special artist, E. F. Mullen," this wood engraving appeared in *Frank Leslie's Illustrated Newspaper* on August 6, 1864. The event depicted took place July 11–12, 1864, during the Battle of Fort Stevens, which occurred two miles south in the District of Columbia. (DCPL.)

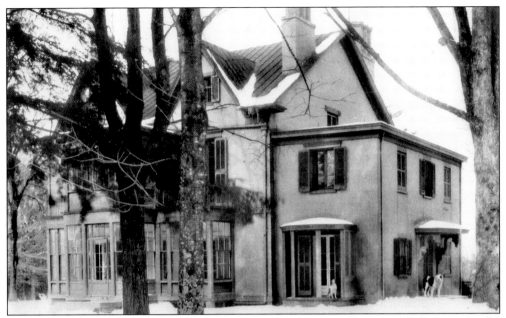

NORTH ELEVATION OF SILVER SPRING MANSION. Two dogs guardedly watch the unknown photographer who took this view in February of 1895. Gist Blair, nephew of Rear Admiral Samuel Phillips Lee and Mrs. (Elizabeth Blair) Lee, described the house: "in the old days of mouse color, and of the type of a French chateau. . . . A fine row of sugar maples lined the walk from the house to the spring." (EBL.)

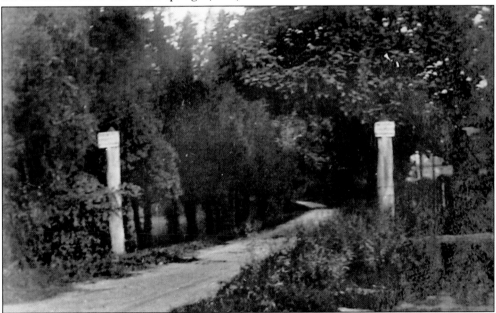

ENTRANCE GATES TO SILVER SPRING ESTATE. This photograph from the album *A Collection of Pictures Showing the Present Condition of the Twenty-Six Original Boundary Stones Between the District of Columbia and Maryland—Pictured and Described by Fred E. Woodward—1905.* Woodward wrote, "Mr. Lee's place is known as Silver Spring, the entrance gates ushering one between rows of massive forest trees." (DCPL.)

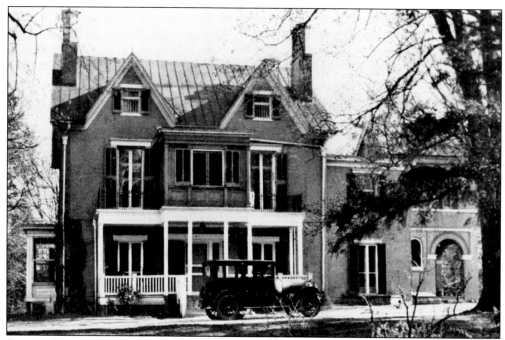

SOUTH ELEVATION OF SILVER SPRING MANSION. An automobile is parked at the front entrance in this 1920s view. Constructed 1842–1845 for Francis Preston Blair as his country estate, the three-story mansion had 20 rooms, four baths, nine fireplaces, two kitchens, and a wine cellar. The mansion was razed in 1954 for construction of an annex to the Blair Station Post Office. (HSW.)

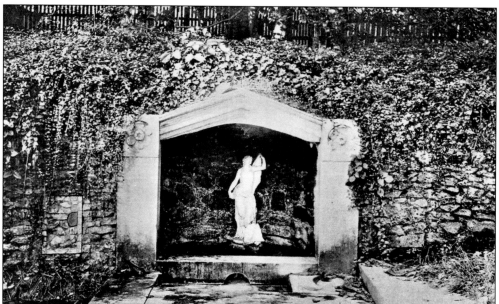

SILVER SPRING GROTTO AND RETAINING WALL. A statue of a Grecian nymph, estimated to have been 30 inches tall, stands inside the Silver Spring grotto in this 1920s view. The grotto's stone surround was installed in 1894 at the bequest of Rear Admiral Samuel Phillips Lee, who resided at Silver Spring with his wife, Elizabeth Blair Lee. (EBL.)

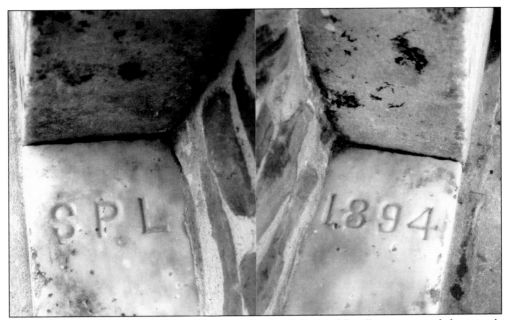

ENGRAVINGS ON SURROUND SILL. On the left side of the marble sill are engraved the initials "SPL" and on the right "1894." These engravings are now under water and usually covered with silt. This photograph was taken in 1997. (JAM.)

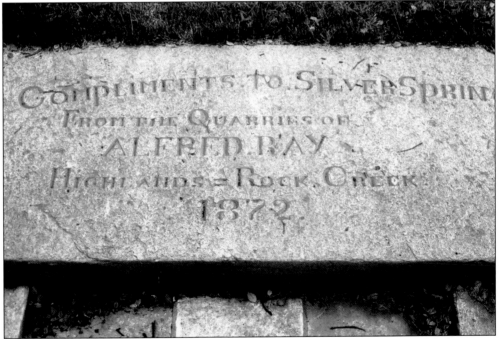

ALFRED RAY'S "CALLING CARD." Knowing that Francis Preston Blair took many of his illustrious guests to view the Silver Spring, quarry owner Alfred Ray donated this estimated two-and-a-half-ton slab of granite for the spring site. The stone reads, "Compliments to Silver Spring. From the Quarries of ALFRED RAY Highlands—Rock Creek. 1872." Ray's estate, Highlands, was located in Forest Glen, Maryland. This photograph was taken in 1997. (JAM.)

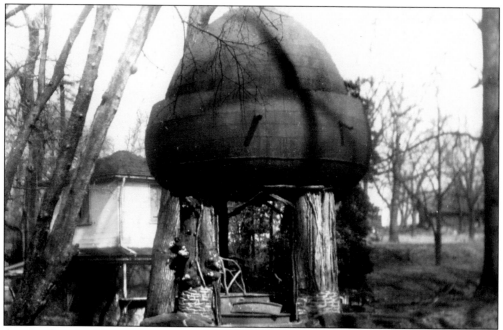

ACORN GAZEBO AND DAIRY HOUSE. Two drainage pipes stick out from the rim of the acorn gazebo in this 1920s view. Note the piece of twig furniture partially visible under the gazebo. Spring water was probably routed through the lower level of the dairy house (left background) prior to the advent of electricity to keep milk and other perishables cool. The photograph was taken by Winn Studio. (EBL.)

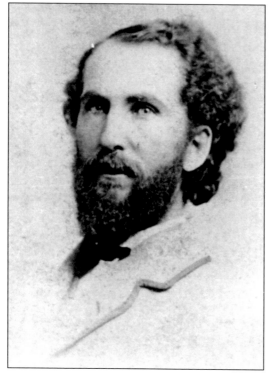

BENJAMIN C. KING, ACORN GAZEBO BUILDER. Born 1829 in Chester, Pennsylvania, King moved in 1851 to what was then called North Takoma, D.C.—the area of the Seventh Street Pike (Georgia Avenue) near the District/Maryland line. King spent 30 years as a contractor and builder, 20 of which were as assistant building inspector of the District of Columbia. He died at his Blair Road home in 1909. (SSHS.)

THE ACORN GAZEBO. This 1967 postcard depicts an oil painting of Silver Spring's 1850s acorn gazebo done by Joseph W. Grabenstein, a technical illustrator at Silver Spring's Johns Hopkins Applied Physics Lab. The postcard was a project sponsored by the United Federation of Postal Clerks, Local 3630. Grabenstein wrote on the postcard's back, "With appreciation of your public support and interest in this card of the Silver Spring." (JAM.)

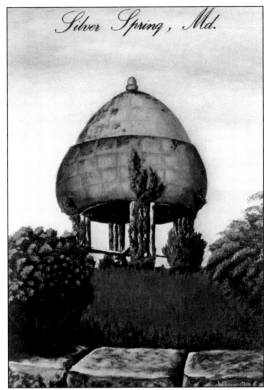

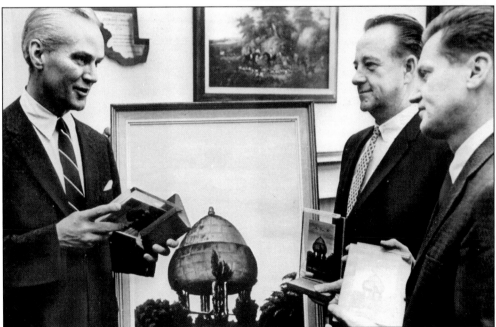

PRESENTATION CEREMONY OF ACORN GAZEBO POSTCARDS. This photograph appeared in the *Evening Star* on December 18, 1967. Pictured from left to right are Sen. Daniel Brewster, (Democrat, Maryland), Silver Spring postmaster Wilburn Leizear, and illustrator Joseph W. Grabenstein. The location of the original oil painting is unknown. (DCPL.)

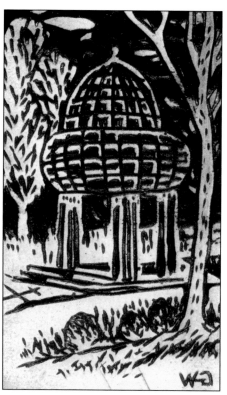

ACORN GAZEBO LINOLEUM BLOCK. The acorn gazebo served as inspiration to an unknown artist who created this 1950s linoleum cut block. The artist's initials, "GW," were reverse-cut into the design. (JAM.)

SILVER SPRING–ACORN PARK LANDSCAPING. Charles Kopeland (below left), executive secretary of the Silver Spring Board of Trade, and Mrs. Betty Heflin, 607 Rosemere Street, Silver Spring, stand on the recently completed staircase and retaining wall surrounding the Silver Spring. The millstone was recovered from nearby Blair Mill Road and perhaps covers an old well shaft. The photograph was taken c. 1955 by Horan. (DCPL.)

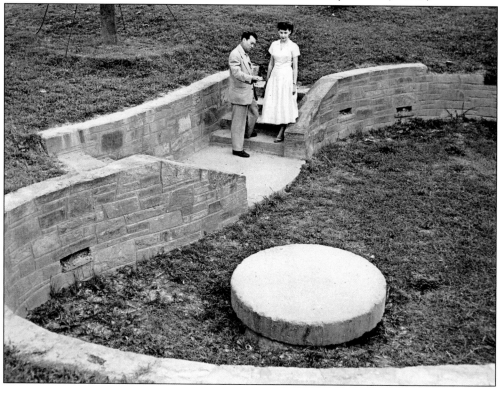

DEDICATION OF THE SILVER SPRING. Blair Lee III, great-great-grandson of Francis Preston Blair, addresses the assembled crowd for the dedication of Acorn Park on May 28, 1955. The spring was dedicated as "an ever-flowing tribute to the men and women responsible for the greatness of Silver Spring, Maryland, and its bright future through civic and community service." (JPH.)

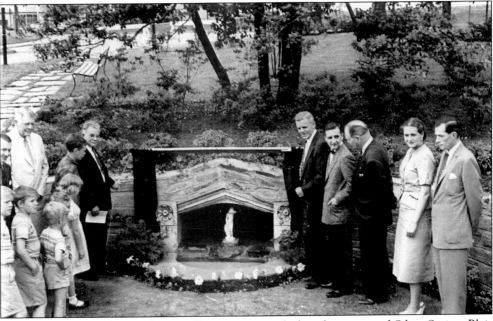

UNVEILING OF THE SILVER SPRING. Dignitaries pose before the renovated Silver Spring. Blair Lee III stands to the right of the grotto, and his uncle, E. Brooke Lee I, stands at the far left in a white jacket. The original statue in the grotto had been accidentally destroyed and was replaced with a near replica. Note the decrease in the height of the grotto's opening in comparison to the 1920s view on page 26. (JPH.)

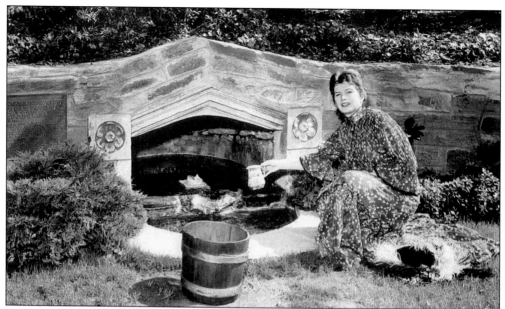

FRANCIS PRESTON BLAIR'S SILVER SPRING. In 1957, the Baltimore Life Insurance Company commemorated its 75th anniversary by commissioning world-renowned photojournalist A. Aubrey Bodine to document communities that the company served. Bodine worked at the *Baltimore Sun* from 1920 until his death in 1970. Sepia gravure prints of the original photograph were distributed to the public free of charge. The identity of the model is unknown. (JAM.)

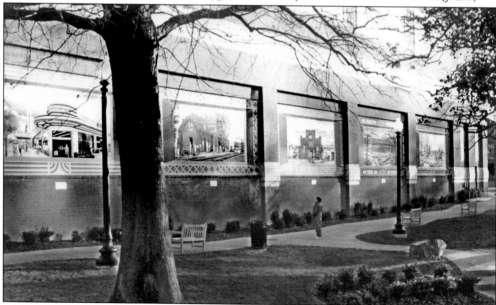

ACORN PARK "MEMORY WALL." As part of Acorn Park's renovation, Washington, D.C., artist Mame Cohalan painted five wall murals in 1995 depicting different periods of Silver Spring's history. The first three murals from the left were based on photographs, and the remaining two utilized artistic license. Acorn Park, a Montgomery County Designated historic site, is owned by the Maryland–National Capital Park and Planning Commission, is located at the corner of East-West Highway and Newell Street. This photograph was taken in 1997. (JAM.)

MONTGOMERY BLAIR (1813–1883). The eldest of Francis and Eliza Blair's four children, Montgomery served as mayor of St. Louis, Missouri, from 1842 to 1843, was attorney for Dred Scott from 1856 to 1857, and was Pres. Abraham Lincoln's postmaster general from 1861 to 1864. As postmaster general, Blair instituted free U.S. city mail delivery, adoption of a money order system, the use of railway mail cars, and an international postal system. (LOC.)

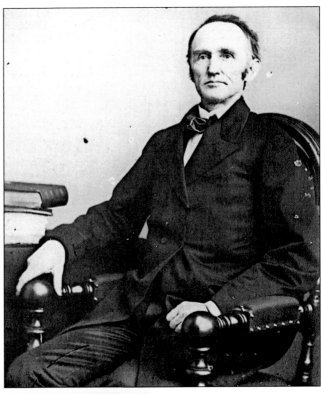

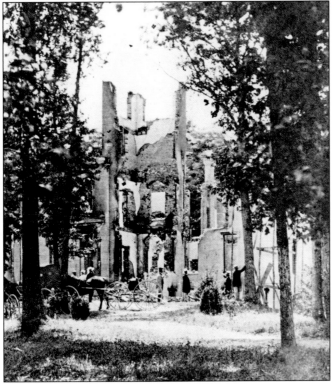

FALKLAND MANSION RUINS. Tourists view the ruins of Montgomery Blair's Falkland mansion, which may or may not have been torched by Confederate troops retreating from their unsuccessful attack on Washington, D.C., at Fort Stevens under the command of Gen. Jubal A. Early, July 11–12, 1864. Blair's son, Gist, stated, "Early burned my father's house. . . . It was a total loss, because although insured it was not insured against the public enemy." (LOC.)

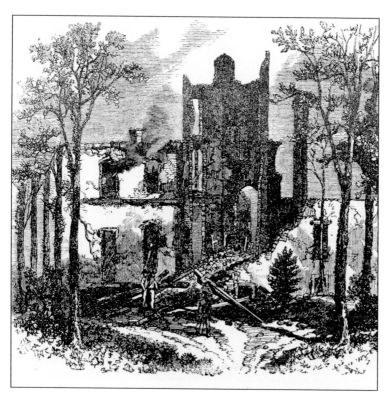

FALKLAND MANSION RUINS ENGRAVING. This wood engraving also appeared in *Frank Leslie's Illustrated Newspaper* on August 6, 1864. Blair's nephew, Blair Lee, recalled that Maj. Gen. John C. Breckenridge sought shelter at the Silver Spring mansion, setting guards to protect it from camp followers, civilian vandals, and looters who had followed the troops: Early did not take this precaution at the Falkland mansion, and it may have been camp followers who burned the home. (DCPL.)

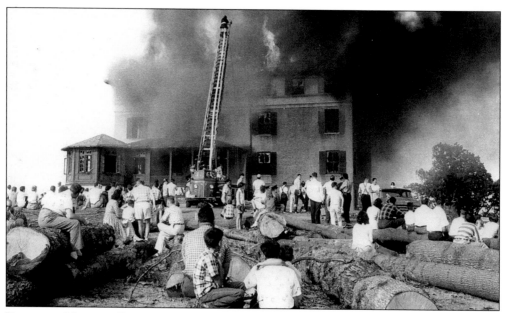

FALKLAND MANSION BURNS AGAIN. Falkland was rebuilt after the Civil War, only to be torched by the Silver Spring Volunteer Fire Department on September 7, 1958. The land, owned by the Blair Management Corporation, was developed for construction of apartments and a "modern" supermarket. This photograph appeared in that day's *Evening Star.* Presently the Blair Shops and The Blairs (apartments) occupy the site. This photograph was taken by Francis Routt. (DCPL.)

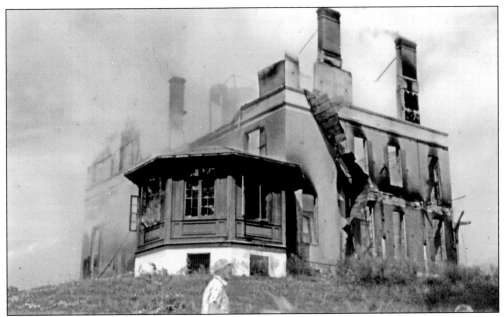

CLOSE-UP OF FALKLAND MANSION IN FLAMES. Prior to the controlled burn, Falkland was being rented out as a boardinghouse. Mrs. Adolphus Staton, a granddaughter of Montgomery Blair who spent much time as a child in the house, said, " I guess burning the mansion down to make way for progress was about as dignified a way for it to go as any." This photograph is by John O'Brien. (DBO.)

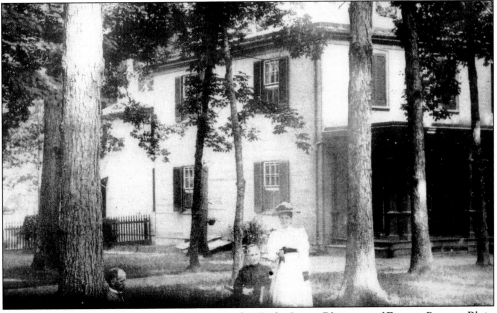

ORIGINAL MOORINGS MANSION. Constructed 1850 for James Blair, son of Francis Preston Blair, the name was derived from the word "mooring," a structure to which a vessel is secured. The country home and surrounding 16-acre property remained in the Blair family until 1933, when Violet Blair Janin, daughter of James, donated it as a public park in perpetuity to the State of Maryland in memory of her brother, Jesup. (HL.)

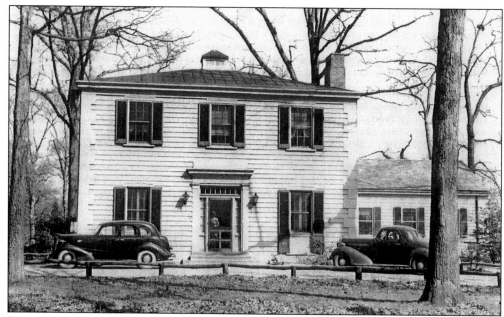

REMODELED JESUP BLAIR COMMUNITY HOUSE, 900 JESUP BLAIR DRIVE. In 1934, architect Howard Wright Cutler remodeled the Moorings mansion for use as the Silver Spring Library. When opened on September 15, 1934, the library's hours were Monday, Wednesday, and Friday from 3:00 to 5:00 p.m. and from 7:00 to 9:00 p.m. The library occupied the structure until 1957. This photograph dates from the 1940s. (SSWC.)

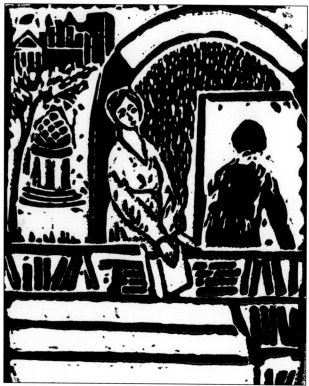

LIBRARY INTERIOR LINOLEUM BLOCK PRINT. Although unsigned, the same artist who cut the acorn gazebo linoleum block (page 30) likely created this design for possible use as a bookplate. Depicted is a librarian behind a reference desk. At the bottom are three horizontal spaces in which a name and address could be written. In the background is the acorn gazebo and beyond that an idealized view of perhaps Washington, D.C. (JAM.)

CHILDREN AT JESUP BLAIR PARK PLAYGROUND. The Stokely children and a friend from the Montgomery Hills neighborhood in Silver Spring take a slide break at the Jesup Blair Park Playground in August 1955. Pictured from left to right are (first row) Jean Stokely and Bonnie Smily; (second row) Ray Stokely and Florence Stokely. Christine Stokely took the photograph. (CSW.)

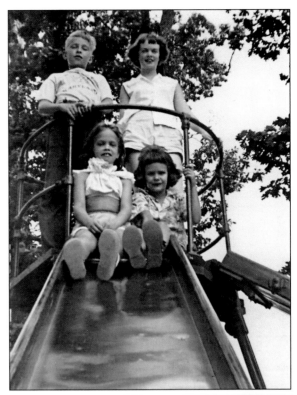

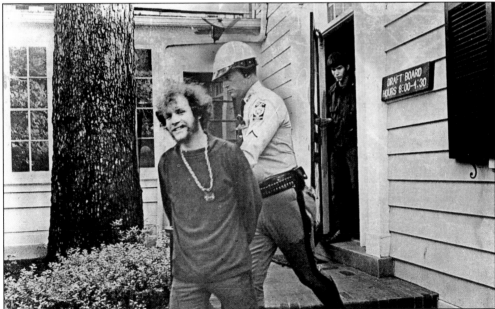

RAID AT SILVER SPRING DRAFT BOARD NO. 53. Two suspects are removed from the Silver Spring Draft Board No. 53 on May 21, 1969. Located in the Moorings mansion, the draft board was vandalized in protest of the Vietnam War. Leslie H. Bayless, 22, and Michael Lee Bransome, 18, both of the District of Columbia, were held under bond. Byron Schumaker took the photograph for the *Evening Star* on May 21, 1969. (DCPL.)

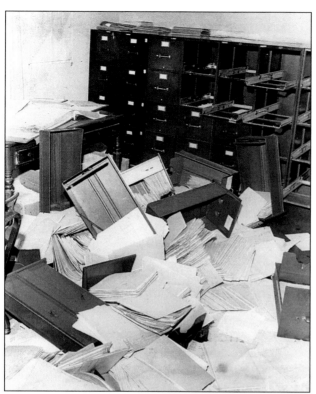

VANDALIZED DRAFT OFFICE RECORDS. The aftermath of the vandalized Silver Spring Draft Board is shown here. Draft record files were scattered, black paint was splashed on the walls, and typewriters were thrown out of windows. The protestors' manifesto stated in part, "We strike at the Selective Service System because it is used to feed the horror of genocide abroad and the suppression of legitimate dissent at home." This photograph was taken by Byron Schumaker for the *Evening Star* on May 21, 1969. (DCPL.)

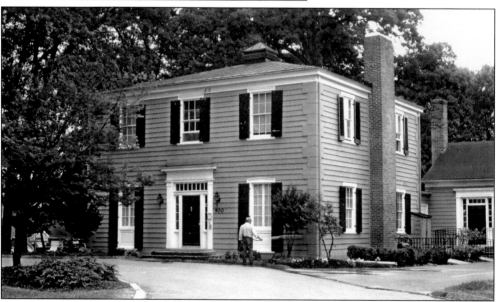

MOORINGS MANSION. As of 2005, the Moorings was being operated by Montgomery County's Housing Opportunities Commission. Jesup Blair Park, administered by the Maryland–National Capital Park and Planning Commission, is located at Georgia Avenue and Blair Road. The mansion and park are listed on Montgomery County's Master Plan for Historic Preservation, and both are deemed eligible by the Maryland Historical Trust for National Register listing. This photograph was taken in 1997. (JAM.)

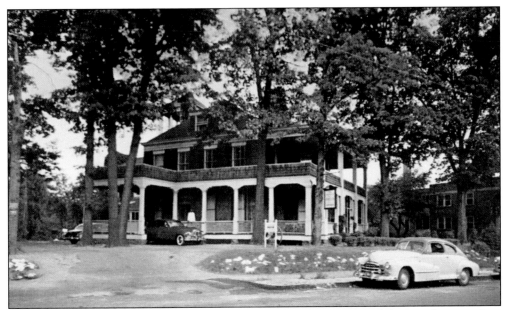

BLAIR MANSION INN, 7711 EASTERN AVENUE. This 1950s postcard depicts the inn when owned and operated by Mrs. Esterlene Bell. The inn was reputedly an 1890 wedding gift from Pierce Shoemaker to his daughter, Abigail C., and son-in-law, Charles R. Newman. The couple were living here in 1900. The mansion is said to have been designed by New York architect Stanford White, but no documentation has surfaced. The photograph is by David Carraway. (JAM.)

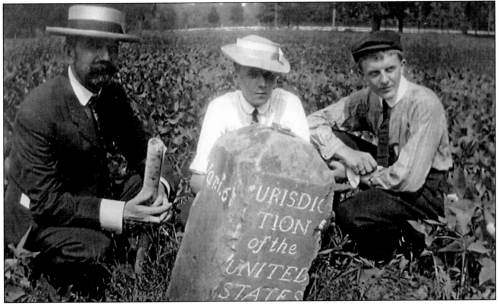

TILTING NORTHEAST NO. 1 BOUNDARY STONE. This photograph is from the album *A Collection of Pictures Showing the Present Condition of the Twenty-Six Original Boundary Stones Between the District of Columbia and Maryland—Pictured and Described by Fred E. Woodward—1905.* The stone was described as standing "in an open cultivated field, on the estate of the Hon. Blair Lee" and "imbedded in a luxuriant growth of cow-peas." (DCPL.)

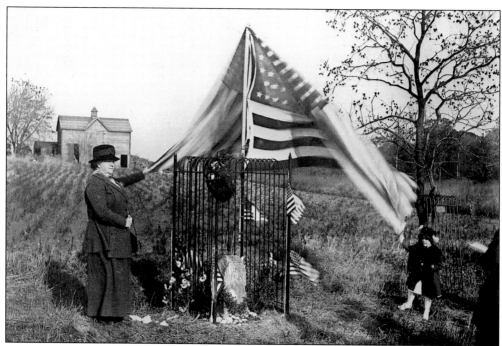

NORTHEAST NO. 1 BOUNDARY STONE. From 1791 to 1792, Andrew Ellicott surveyed land ceded by Maryland and Virginia to the United States for the proposed seat of the federal government. Forty stone markers were placed at one-mile intervals along the boundary of a 10-mile square forming the original District of Columbia. The Mary Washington Chapter of the Daughters of the American Revolution dedicated the iron fence on June 13, 1916. (DCPL.)

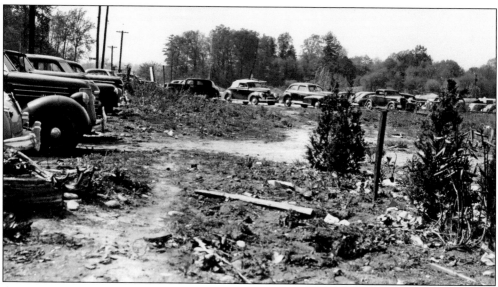

AUTOMOBILES PARKED ON EASTERN AVENUE AND KING STREET. Barely visible in this 1949 view (left near telephone poles) is the battered iron fence erected three decades earlier to protect the Northeast No. 1 boundary stone. Vehicle occupants are attending a carnival set up in an open field between King and Thirteenth Streets. (EBL.)

LAWRENCE GREATER SHOW CARNIVAL GROUNDS. This view looks southeast with Thirteenth Street in the foreground. The building in right background is 7835 Eastern Avenue. Legible signs are "Casino" and "Fearless Stars Mid-Air Acrobats." (EBL.)

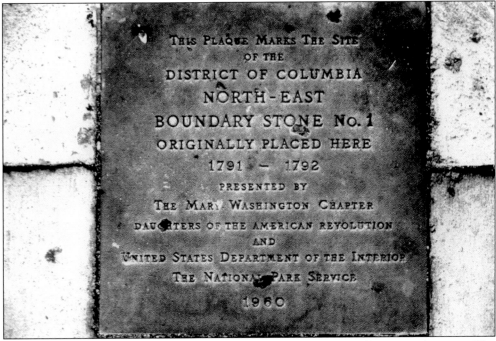

BRONZE PLAQUE REPLACES MISSING BOUNDARY STONE, 7847 EASTERN AVENUE. The original Northeast No. 1 boundary stone disappeared around September 1952 along with its fence. A bronze plaque marking the location of the stone was dedicated on January 12, 1961. It is set into the sidewalk that fronts a commercial property. This site and Southwest No. 2 are the only locations where the original boundary stones are missing. (SSHS.)

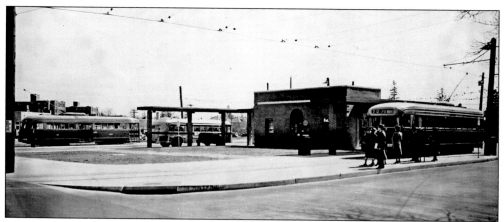

CAPITAL TRANSIT COMPANY BUS AND TROLLEY TERMINAL, 7826 EASTERN AVENUE NW.
A Route 70 PPC (President's Conference Car) idles at the terminal located in the District of Columbia. Capital Transit's franchise was revoked on August 14, 1956, and D.C. Transit assumed operations with the condition that streetcars be eliminated. This was finally accomplished on January 27, 1962. This 1950s photograph was taken by the Stewart Brothers. (DCPL.)

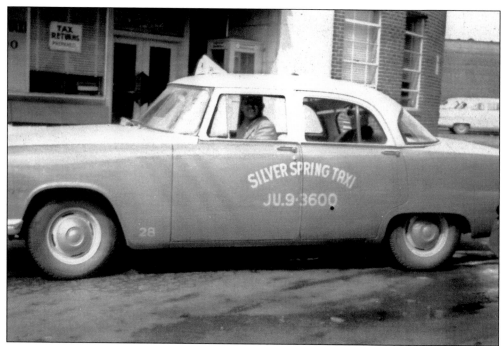

SILVER SPRING TAXI STAND, 7825 EASTERN AVENUE. "Burley Weakley, operator and independent owner leaving District Line" is shown here according to the back of this photograph. Lee W. Jones Sr., president of Silver Spring Taxi, operated Silver Spring's first taxi company in 1931. This photograph dates from the 1950s. (BI.)

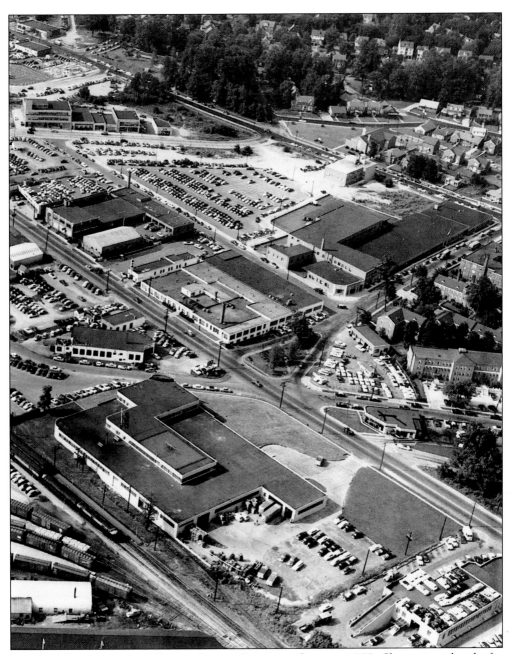

AERIAL VIEW OF SOUTH SILVER SPRING LOOKING SOUTH, 1955. Shown is a detail of a photograph by Francis Routt appearing in the *Evening Star* on July 15, 1955. East-West Highway (center diagonal) and Eastern Avenue NW (top diagonal) divide the image into thirds. At the bottom third is the 1946 Canada Dry Bottling Plant (left with large front yard) and the 1947 Monroe Ford (right with cars parked on rooftop). The center third is the 1944–1950 Emerson Research Laboratories (facing triangular Acorn Park, bordered by Newell Street on two sides). In the next block, on Newell Street, are the 1950–1954 Blair Station Post Office and Annex and the single-story 1952 U.S. Geological Survey. The top third is the Shepherd Park neighborhood in the District of Columbia. (DCPL.)

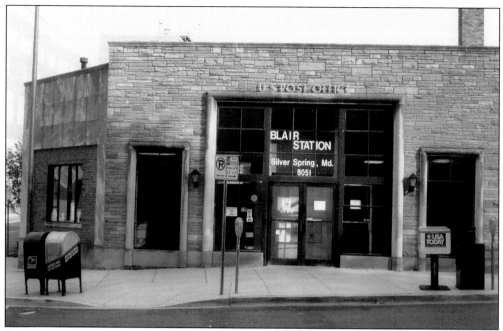

BLAIR STATION POST OFFICE, 8045 NEWELL STREET. Constructed in 1950, the Blair Station Post Office served as the test site in 1957 of the Transorma, the first semi-automatic mail sorting machine successfully tested in the United States. The post office was razed in 2003 for construction of loft-style condominiums. This photograph was taken in 1997. (JAM.)

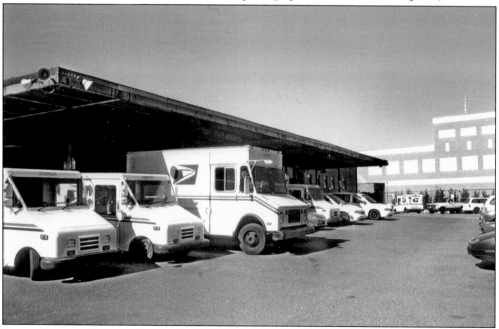

BLAIR STATION POSTAL ANNEX LOADING DOCK. This view is taken from the same vantage point as that depicted of the south elevation of the Francis Preston Blair's Silver Spring mansion (page 26). Constructed shortly after the mansion was razed in 1954, the loading dock annex was razed along with the post office in 2003. This photograph was taken in 1999. (JAM.)

PLAT SHOWING BLAIR STATION POST OFFICE AND ANNEX OVERLAID ONTO SILVER SPRING MANSION, C. 1954. The footprint of Francis Preston Blair's Silver Spring is depicted in relation to the footprint of the 1954 postal annex. (SSHS.)

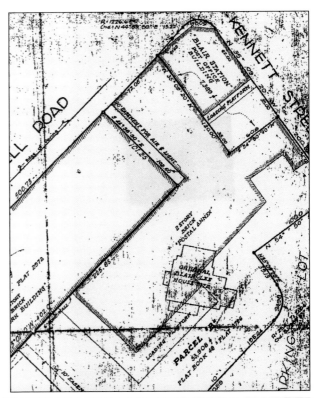

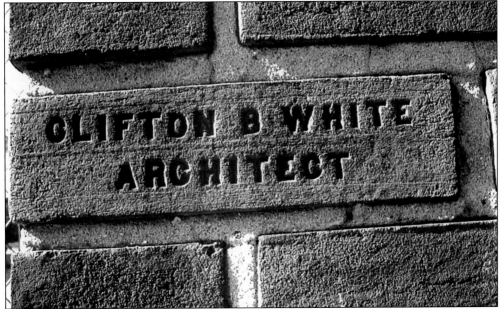

CLIFTON B. WHITE (1890–1962) SIGNATURE BRICK. White, who designed the 1954 Blair Station Post Office and Annex, had this incised brick imbedded in the Kennett Street façade of the annex. A member of the American Institute of Architects, White's works included churches, residences, commercial, and industrial buildings. The brick is now in the collection of the Silver Spring Historical Society (SSHS). This photograph was taken in 2003. (JAM.)

LAST DAY OF THE BLAIR STATION POST OFFICE. U.S. Postal Service window clerks Antonio M. Wade (left) and Jackie Williams pose on the last day of operations at the Blair Station Post Office, November 26, 1999. That same month marked the 50th anniversary of the post office's opening. The Blair Station Post Office has not reopened. (JAM.)

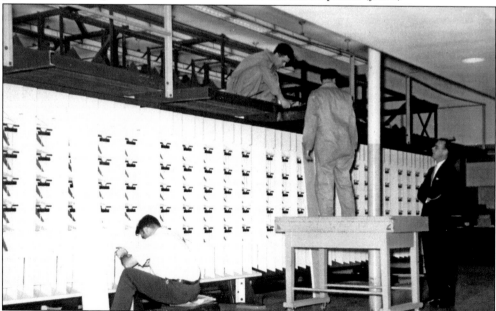

INSTALLATION OF TRANSORMA. Pitney-Bowes technicians install the Transorma on January 24, 1957. The name was derived from the words transport, sorting, Marchand, and Andriessen (the latter two being Transorma's Dutch inventors). Transorma was 50 feet long, 13 feet high, and weighed 31,000 pounds. Five operators sat at letter-feeding devices positioned on the upper level, where they assigned code numbers to letters based on the letters' destinations. (SSPO.)

TRANSORMA LETTER-FEEDING DEVICE. Operators sat at this machine, where 50 letters shot by per minute. Having memorized 300 separation codes, operators punched in a code for each letter that routed them into appropriate boxes positioned below. One operator could sort 3,000 letters into 300 boxes per hour, whereas one mail clerk could hand-sort 1,500 letters into no more than 75 boxes in the same amount of time. (SSPO.)

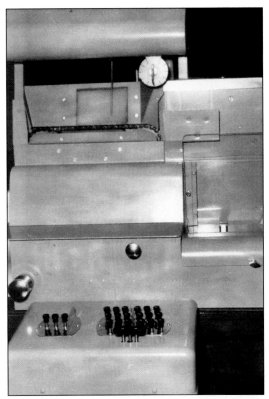

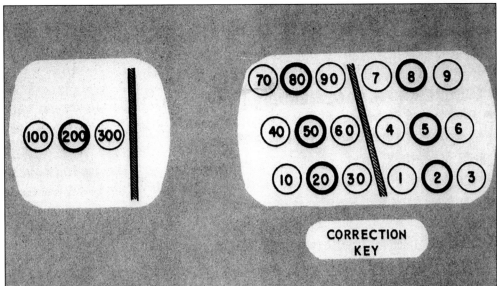

TRANSORMA KEYBOARD SCHEMATIC. In February 1957, the U.S. Post Office published a manual to acquaint Silver Spring Post Office personnel with Transorma's operation. Positioning for each operator's fingers to strike keys was as follows: left hand ring finger–100, middle finger–200, and index finger–300; right hand index finger–10 to 90, middle finger–1, 4, and 7, ring finger–2, 5, and 8, and little finger–3, 6, and 9. Code keys had to be depressed simultaneously after the letter left the "reading" position. (SSPO.)

6 B #6	11 B #11	16 B #16	21 B #21	26 B ER	31 Main Office Bxs.	36 Bank Silver Spring	41 Commerce	46 Household Finance	51 National Institute	56 Sears Roebuck	61 Sun Life Ins.	66 Wooten Refuse
7 B #7	12 B #12	17 B #17	22 B ER	27 B ER	32 Aetna Finance	37 Buick	42 Food Barn	47 Maryland Cash Co.	52 Oldsmobile	57 Singer Co.	62 U.S. Geological	67 Silver Spring, Md.
8 B #8	13 B #13	18 B #18	23 B ER	28 Silver Spring Postmaster	33 American Gas Co.	38 Bullis	43 Holy Trinity	48 Metropolitan Life Ins.	53 Seaboard Finance	58 State Farm	63 Universal C.I.T.	68 B Postage Due
9 B #9	14 B #14	19 B #19	24 B ER	29 Wash., D.C. Unzoned	34 American Instrument	39 C & P Telephone Co.	44 Fisher Scientific	49 Johns Hopkins	54 Naval Ordnance	59 Prudential Ins.	64 Suburban Trust Co.	69 Misdirects

SILVER SPRING TRANSORMA SEPARATION CODES. Included in the same manual were box diagrams detailing the 300 codes that operators had to memorize. Illustrated here are codes for Silver Spring destinations "36 Bank Silver Spring" and "64 Suburban Trust Co." The Transorma was precursor to the zip code, introduced in 1963, and was described by Postmaster General Arthur Summerfield as "a breakthrough" in the handling of mail. (*New York Times*, May 6, 1957). (SSPO.)

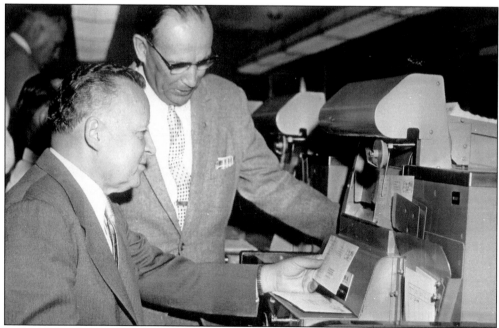

INAUGURAL OPERATION OF THE TRANSORMA MAIL SORTING MACHINE. Postmaster General Arthur Summerfield (left) and Silver Spring postmaster William E. Bowman pose with a first day cover that was just routed through the Transorma letter-feeding device at the Blair Station Post Office on May 2, 1957. On this date, Pitney-Bowes, Inc., who installed and tested the equipment, officially turned operations over to the U.S. Post Office Department. (SSPO.)

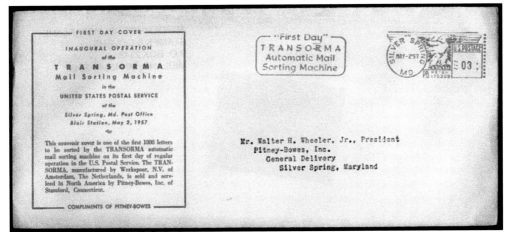

Transorma First Day Cover. Addressed to Walter H. Wheeler Jr., president of Pitney-Bowes, Inc., this first day cover was one of 1,000 souvenir envelopes to be sorted by the Transorma automatic mail-sorting machine on May 2, 1957. The envelope's cachet (text imprinted on the left) misidentifies the U.S. Post Office Department as the "U.S. Postal Service," a name that did not come into use until 1971. (SSHS.)

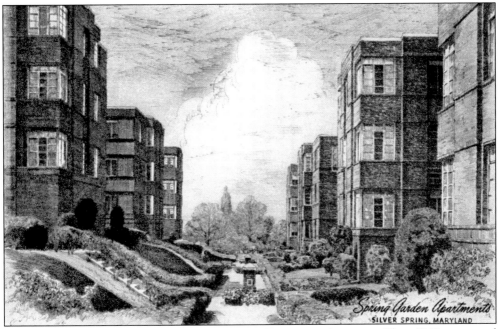

Spring Garden Apartments, 8001–8031 Eastern Avenue. This 1940s postcard depicts a rendering of the original 1941 Spring Garden Apartments complex, designed by George T. Santmyers, as viewed from Eastern Avenue. Real-estate developer Morris Miller constructed these and numerous other Silver Spring apartment projects in addition to hundreds of homes. Morris Miller Liquor, established by Miller in 1933, still operates at 7804 Alaska Avenue NE in Washington, D.C. (JAM.)

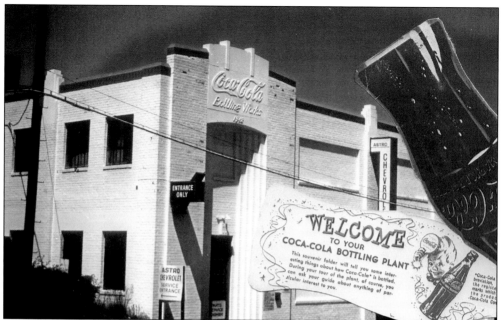

COCA-COLA BOTTLING WORKS, 1110 EAST-WEST HIGHWAY. Constructed in 1941 and opened the following year, this Washington Coca-Cola Bottling Company plant remained in operation until 1967, when it was relocated to 1710 Elton Road in Silver Spring. The overlaid 1960s souvenir folder was given to visitors who toured the bottling works. The photograph was taken 1988 by Judy Reardon. The folder is courtesy of John Sery. (SSHS.)

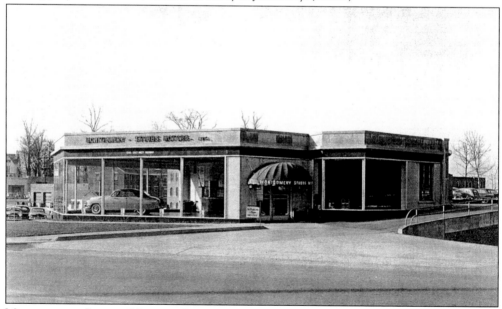

MONTGOMERY-STUBBS MOTORS, INC., 1200 EAST-WEST HIGHWAY. Constructed in 1947 on the corner of Blair Mill Road, this was a Lincoln-Mercury automobile dealership. By 1949, a total of five dealers were located on East-West Highway between Georgia Avenue and Colesville Road, with an additional seven located in the downtown Silver Spring vicinity. The photograph is by Theodor Horydczak. (LOC.)

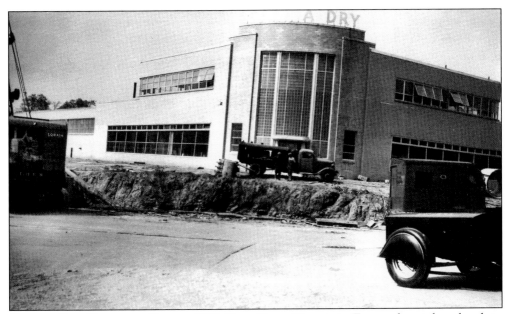

CANADA DRY BOTTLING PLANT, 1201 EAST-WEST HIGHWAY. Two workers take a break in front of the nearly completed 1946 Canada Dry Bottling Plant, designed by New York City industrial architect Walter Monroe Cory in the streamlined moderne style. A concrete staircase remains to be constructed in front of the circular vestibule entrance. The staircase will lead down to the intersection of East-West Highway and Blair Mill Road. (EBL.)

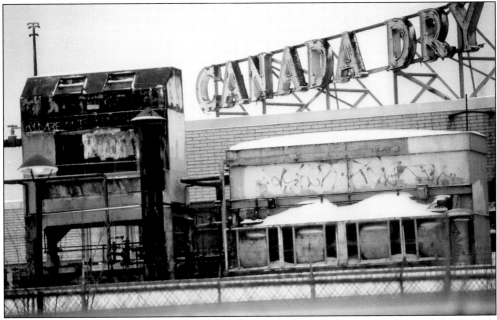

CANADA DRY NEON SIGN. This original neon sign sat atop the second floor of the Canada Dry Bottling Plant facing the B&O Railroad tracks. Its neon green glow was visible at night to passersby on Georgia Avenue and the Metro. The sign was accidentally destroyed in 2003 during demolition of the trackside portion of the plant and is going to be recreated. This photograph was taken in 2000. (JAM.)

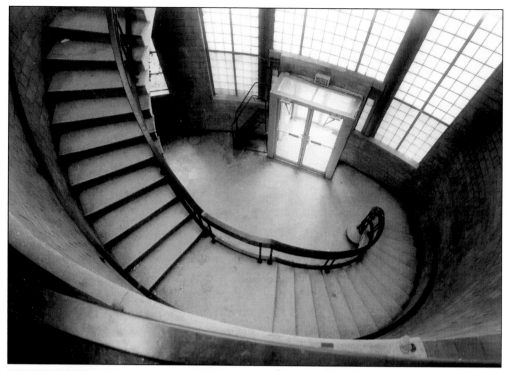

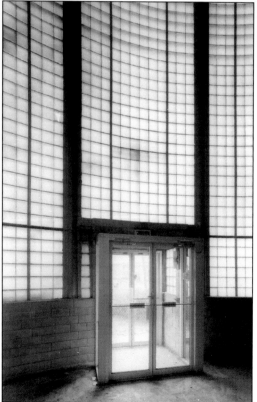

CANADA DRY BOTTLING PLANT ENTRANCE VESTIBULE STAIRCASE. A terrazzo staircase with a decorative, open, flat-iron railing is partially cantilevered from the curving, glazed brick wall of the vestibule, whose color is reminiscent of ginger ale. The two-story vestibule, staircase, and terrazzo floor will be restored to its 1946 appearance, serving as an entrance to the Silverton Condominium and featuring historic displays. This photograph was taken in 2003 by Jet Lowe. (HAER.)

CANADA DRY BOTTLING PLANT ENTRANCE VESTIBULE WINDOW. A two-story glass-block window provides lighting into the entrance vestibule. The opacity of the bottom half was decreased due to horizontal striations in the individual glass blocks while vertical striations in the blocks at the top allowed more light to enter. This additional light filtered into the second floor area, where the administration offices were located. This photograph was taken in 2003 by Jet Lowe. (HAER.)

CANADA DRY BOTTLING PLANT SECOND FLOOR ADMINISTRATION OFFICES. At the top of the circular vestibule's staircase was the entrance to the plant's administration offices. Horizontally ribbed window glass provided diffused light into the offices. The office door is now in the collection of the SSHS. This photograph was taken in 2000. (JAM.)

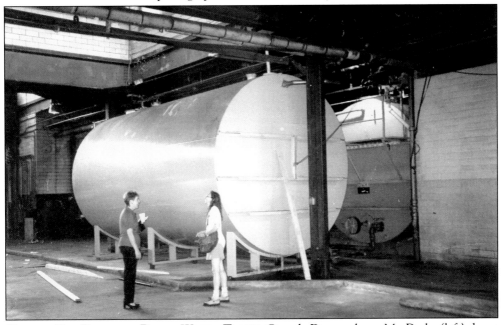

CANADA DRY BOTTLING PLANT WATER TANKS. Canada Dry employee Ms. Darby (left) shows Marcie Stickle two of the bottling plant's four water tanks. The facility ceased operations in 1999. Prior to demolition, a Historic American Engineering Record was conducted during the winter of 2002–2003, resulting in measured drawings and photographs that were deposited with the American Memory Project at the Library of Congress (Call Number HAER, MD-131). The photograph was taken in 2000. (JAM.)

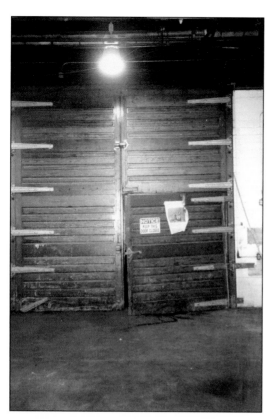

CANADA DRY BOTTLING PLANT REFRIGERATOR DOORS. These wooden doors led to the refrigerated syrup room and were large enough to accommodate forklifts. A smaller door on the right, slightly ajar in this 2000 photograph, allowed individual entry. (JAM.)

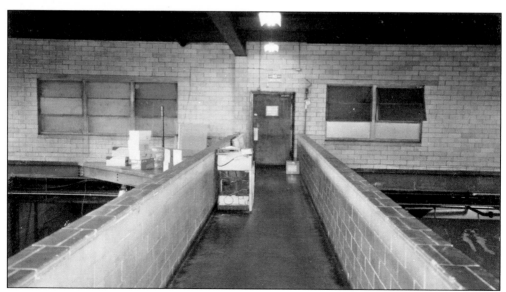

CANADA DRY BOTTLING PLANT CATWALK. This second-floor catwalk provided a view of the bottling plant's operations on the ground floor. This 2000 view looks toward the administration offices. In 2003, the majority of the complex was razed except for the two-story circular vestibule and original projecting façades, which will be adaptively reused in the construction of the Silverton Condominiums. (JAM.)

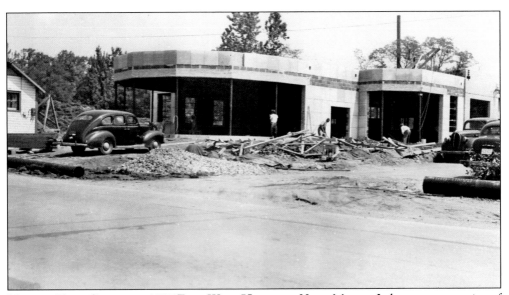

MONROE FORD COMPANY, 1237 EAST-WEST HIGHWAY. Harry Monroe Jr. began construction of his automobile dealership in 1947 next door to the Canada Dry Bottling Plant. To accommodate more automobiles on a relatively small lot, a ramp at the rear of the building led to a rooftop parking lot. (EBL)

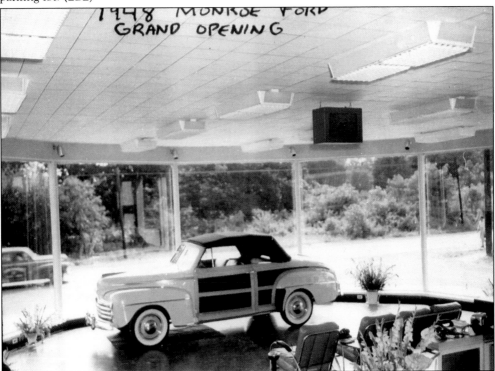

MONROE FORD COMPANY GRAND OPENING. This interior view shows a 1948 Ford "Woody" sedan convertible visible to passing cars and pedestrians on East-West Highway. Former employee Gary Levy recalled that when he started working at Monroe Ford in 1972, the same tubular chrome chairs were still in the showroom. (GL.)

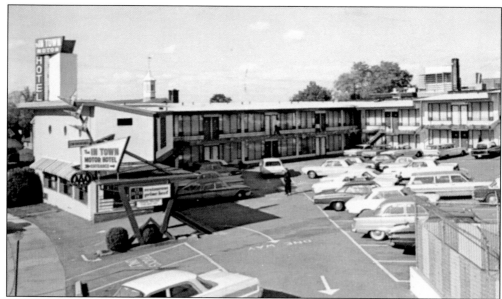

IN TOWN MOTOR HOTEL, 8000 THIRTEENTH STREET. This postcard was mailed from Silver Spring on August 26, 1966, from Bill, who wrote, "Arrived here 7:30 pm about 400 miles. That is enough for me." The 1956 motor hotel offered 77 modern rooms within walking distance of Rock Creek Park, churches, a synagogue, and shopping areas. Public transportation was available at the door, and a restaurant, swimming pool, and parking were available on site. (JAM.)

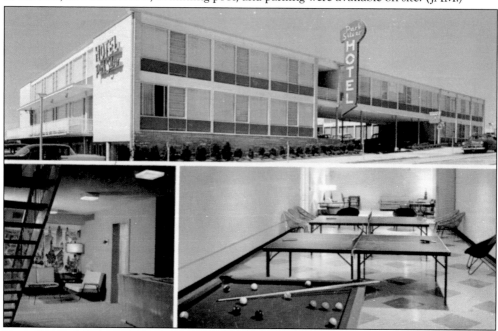

PARK SILVER MOTEL, 8040 THIRTEENTH STREET. This 1950s postcard depicts the 1956–1957 Park Silver Motel, billed as "Silver Spring's First and Finest." Offered were 66 guest rooms with kitchenettes, in addition to a recreation room (bottom right), meeting rooms, TV, laundry facilities, ice, bonded babysitters, and continental breakfast. Several tourist motels were grouped together in South Silver Spring due to its close proximity to the nation's capital. (JAM.)

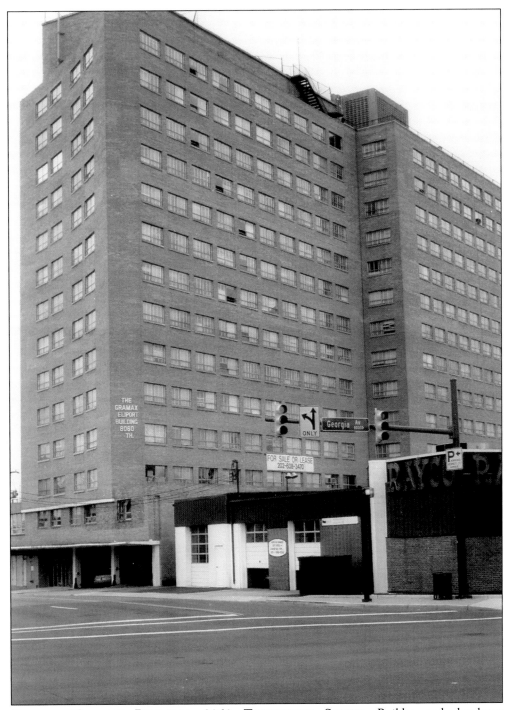

GRAMAX HELIPORT BUILDING, 8060 THIRTEENTH STREET. Builder and developer William Robinowitz opened the Gramax in 1965. Robinowitz proposed to offer helicopter service to link downtown Silver Spring with area airports. The Montgomery County Board of Appeals approved the plan in July 1964 but 14 months later reversed its decision. No documentation has surfaced indicating helicopters landed on the roof. The photograph was taken in 1997. (JAM.)

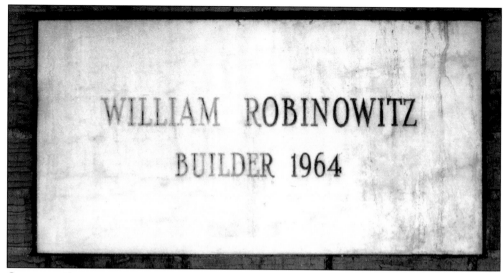

GRAMAX HELIPORT BUILDING CORNERSTONE. Born in Russia, Robinowitz emigrated to the United States in 1913 and lived in High Point, North Carolina, before moving to the Washington, D.C., area in 1922. He graduated from George Washington University and started Robin Construction Company about 1949. Gramax is a combination of the names of Robinowitz's children, Grace and Max. The cornerstone was buried under a 2003 façade renovation. This photograph was taken in 1997. (JAM.)

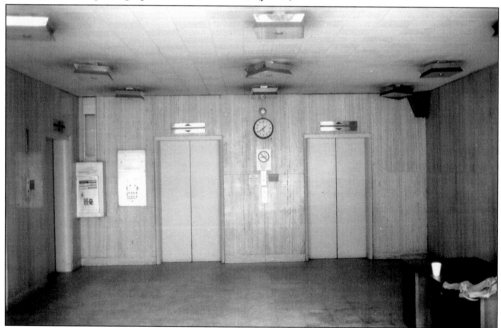

GRAMAX HELIPORT BUILDING LOBBY. When opened in 1965 the Gramax was Silver Spring's tallest building. The $3-million, 14-story structure had 130,000 rentable square feet and interior parking for 200 cars. Vacant for nearly a decade, the building was purchased in 2003 and underwent a $25-million renovation that completely altered the façade and gutted the interior. Today the Gramax Towers contain apartments and the Gateway Heliport Gallery. This photograph was taken in 1997. (JAM.)

58

Three

MAIN STREETS OF HISTORY
Georgia Avenue and Colesville Road

Downtown Silver Spring is unique in that it possesses two "Main Streets," Georgia Avenue and Colesville Road. A walk along either of these busy thoroughfares allows the urban explorer to experience a virtual time capsule of Silver Spring's history. Buildings fronting these two roadways were constructed during each of the last nine decades of the 20th century and into the 21st, collectively symbolizing the community's past and serving as its visual identity.

In 1849, the Union Turnpike Company was established to build a road from Washington, D.C., to Brookeville, Maryland. Known as the Washington and Brookeville Turnpike, the artery ran through the then-named Sligo, Maryland. The turnpike was also known as the Seventh Street Pike as well as Brookeville Avenue. A toll gate was located near the present intersection of Georgia Avenue and Ellsworth Drive. Around 1906, the turnpike was renamed Georgia Avenue, a name previously given to an avenue in Southeast Washington, D.C., whose western terminus was in Southwest D.C. Sen. Augustus Octavius Bacon (Democrat from Georgia), not pleased that the great state of Georgia was represented in the nation's capital by such an undistinguished avenue, was instrumental in having the name transferred to Northwest Washington, D.C. The original Georgia Avenue is now Potomac Avenue SE and SW.

The Washington, Colesville, and Ashton Turnpike Company was established in 1864 to operate the Ashton, Colesville, and Sligo Turnpike (Colesville Road), which ended at the Brookeville Turnpike. Toll Gate No. 1 was located just as travelers approached the end of the turnpike at Sligo. The small wooden structure closed in 1910 with the death of its last toll keeper, Henry Charles Ulrich (born 1849). By c. 1915, all privately run turnpikes had ceased operations with the establishment of Maryland's State Roads Commission.

Future redevelopment pressures will potentially erode the rich tapestry of buildings located along both routes, buildings that present a veritable timeline of Silver Spring's history. Continued education emphasizing the importance of these historic structures and their potential for adaptive reuse will enable future residents and visitors to experience our community's unique past.

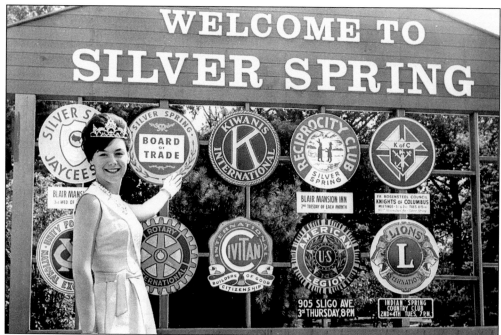

"WELCOME TO SILVER SPRING" SIGN, NORTHEAST CORNER OF GEORGIA AVENUE AND BLAIR ROAD. "Barbara Chamberlin, who was chosen as this year's Miss Silver Spring in a competition sponsored by the Silver Spring Junior Chamber of Commerce, adds beauty to a newly installed sign in Jesup Blair Park listing some of the community's organizations." The photograph by Owen Duvall and caption appeared in the *Evening Star* on July 24, 1963. (DCPL.)

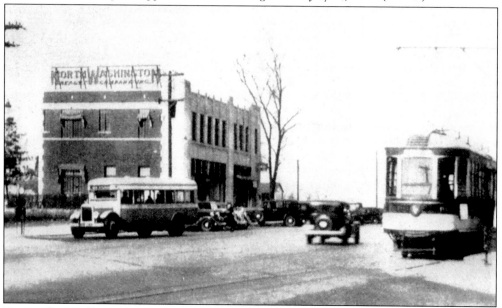

END OF STREET RAILWAY LINE, NORTHEAST CORNER OF GEORGIA AVENUE AND BLAIR ROAD. "Capital Transit Street Railway (right) and Express Bus Service to downtown business section." The building in the background is the North Washington Realty Company, 7900–7912 Georgia Avenue. The photograph and text is from *Maryland News*, June 22, 1934. (SSHS.)

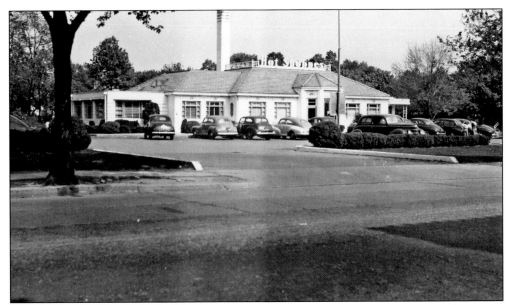

HOT SHOPPES DRIVE-IN RESTAURANT, 7980 GEORGIA AVENUE. In 1927, J. Willard Marriott opened a nine-stool A&W Root Beer stand, later called The Hot Shoppe, at 3128 Fourteenth Street NW in Washington, D.C. By 1947, when this photo was taken, there were 15 Hot Shoppes located throughout the Washington metropolitan area. In 1951, a second Silver Spring location opened at 8643 Colesville Road. (EBL.)

REMODELED HOT SHOPPES, 7980 GEORGIA AVENUE. "Remodeling of this busy Hot Shoppes Restaurant . . . has resulted in a 'new look' and also increased the big units seating capacity and service facilities." This location closed *c.* 1975, and the last business to occupy the structure was The Piano Shop. The building was razed in 2000. The photograph by Adams Studio Custom Photography and caption appeared in the *Evening Star* on August 10, 1950. (DCPL.)

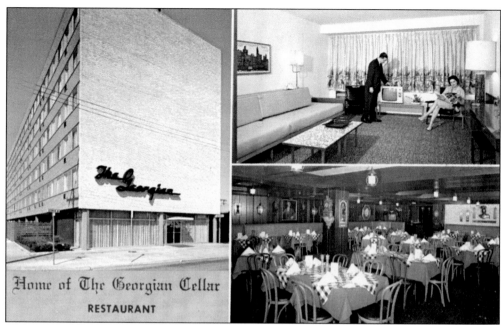

GEORGIAN MOTEL, 7990 GEORGIA AVENUE. This postcard for the Georgian Motel, opened March 17, 1961, proclaims, "Overlooking the Nation's Capital—One block from the Washington, D.C. line. 125 luxurious rooms and suites." Designed by Collins-Kronstadt and Associates of Silver Spring, the $1-million ($6.2 million in 2005 dollars) hotel was developed by Silver Spring businessman Sam Eig. (JAM.)

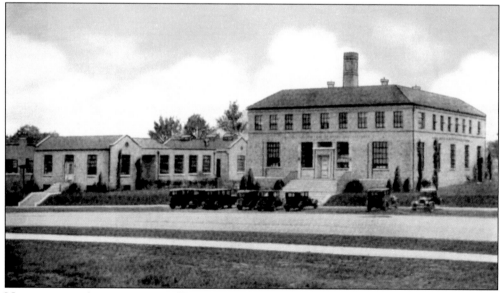

NATIONAL ASSOCIATION DYERS AND CLEANERS (NADC) INSTITUTE, 8001–8021 GEORGIA AVENUE. This postcard was published in 1931 by Curt Teich and Company, Inc., of Chicago. Company records indicate a run of 2,000 postcards ordered by Lloyds, Inc., perhaps a dry cleaner operator. S. Hugh Lloyd wrote on this card, cancelled in Springfield, Missouri, in 1931, "This is where I spent the last two months in school. Was surely glad to get back on the job at Lloyds." The institute opened in 1927. (JJV.)

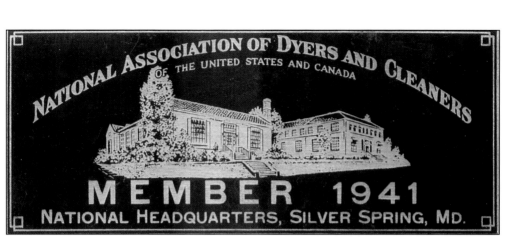

NADC Brass Membership Sign. Dry cleaner operators who had completed the eight-week long course were eligible for yearly NADC membership. Metal signs such as this were displayed in shops, attesting that the owners offered professional services. On April 15, 1941, NADC had 2,419 members, losing 24 by December of that year with the start of World War II. (JAM.)

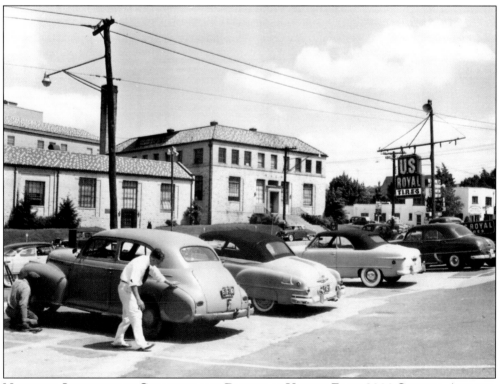

National Institute of Cleaning and Dyeing as Viewed from 8000 Georgia Avenue. A 1947 name change followed a 1944 addition (left) by Arthur B. Heaton. Heaton's architectural drawings for the entire NADC campus are housed in the Library of Congress. The buildings are listed on Montgomery County's Locational Atlas and Index of Historic Sites. Vehicles in the foreground of this c. 1952 photograph await servicing at Silver Spring Tire Corporation. (KL.)

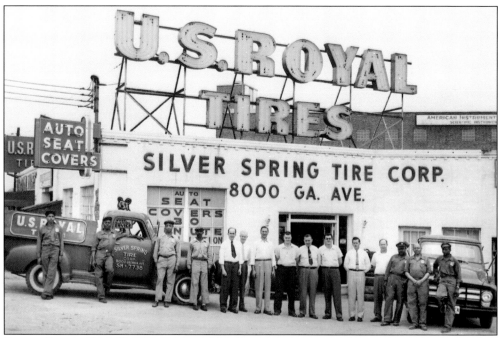

SILVER SPRING TIRE CORPORATION, 8000 GEORGIA AVENUE. This structure, constructed in 1937, was occupied *c.* 1940 by Marcy Motors, a Chrysler-Plymouth sales and service dealer. In 1952, Leon Lubel opened the Silver Spring Tire Corporation. These unidentified employees pose in June 1954. (KL.)

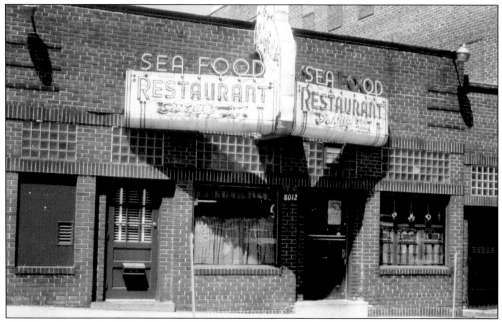

CRISFIELD'S SEAFOOD RESTAURANT, 8012 GEORGIA AVENUE. Crisfield's, named after Crisfield, Maryland, was established in 1945 by Henry and Lillian Landis. The original vintage neon sign with red lobster, a Silver Spring landmark for over half a century, has since been replaced by a contemporary neon version. This photograph was taken in 1987 by Judy A. Reardon. (SSHS.)

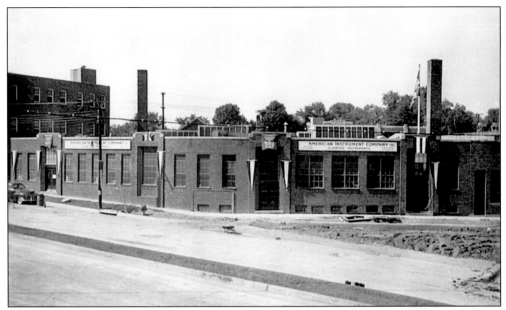

AMERICAN INSTRUMENT COMPANY, INC., 8040 GEORGIA AVENUE. Established 1919 in Washington, D.C., by William H. Reynolds and Leopold Freeman, the American Instrument Company (AMINCO) constructed this building, photographed in 1948, in three stages between 1935 and 1943. The company specialized in construction of precision testing instruments and laboratory apparatus. In 1953, work was under way on AMINCO's fourth atom smasher for the Atomic Energy Commission. (JCR.)

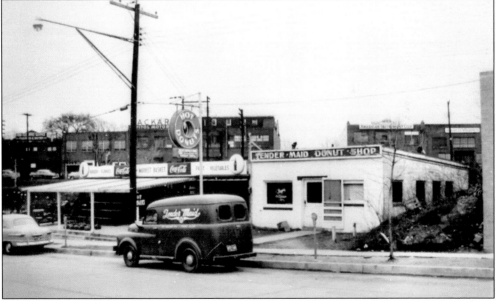

TENDER MAID DONUT SHOP, 8035 GEORGIA AVENUE. This photograph, c. 1950–1953, shows the second location of what later was named Montgomery Donuts. In 1946, William Thurman Mayo opened the Dixie Cream Donut Shop at 8041 Georgia Avenue. When construction began on the Georgia Avenue underpass in 1947, the B&O tracks were temporarily rerouted and Mayo's original shop razed. In 1948, the B&O erected this structure for Mayo. (MCHS.)

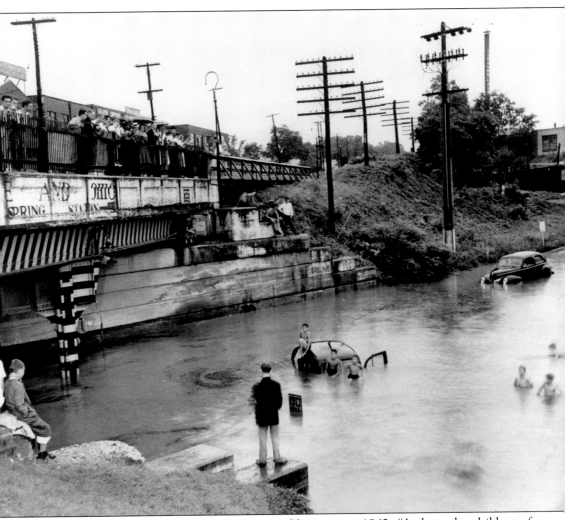

SOUTH SIDE OF FLOODED GEORGIA AVENUE UNDERPASS, 1942. "At least the children of Silver Spring received some benefit from yesterday's rainstorm which flooded Georgia Avenue beneath the Baltimore & Ohio Railroad underpass to a depth of five feet. Here they are shown as they frolicked in the pool amid two stalled cars. After several hours of pumping and draining, motorists proceeded cautiously through a thick layer of mud left on the street." The photograph and quote appeared in the *Evening Star*, July 21, 1942. Constructed in 1928, the underpass, or viaduct as it was also called, was the site of hundreds of vehicular accidents, including at least one known fatality. Mrs. Elna Gerlac Allen, 55, died on September 24, 1940, after crashing her vehicle into one of the underpass's steel girders. Fred L. Lutes, chairman of the Silver Spring Business Men's Association, sent telegrams immediately to Maryland's elected officials to renew a 10-year effort to replace the underpass. Lutes concluded the association's protest with, "For the sake of humanity, will you do something now to stop this slaughter?" (DCPL.)

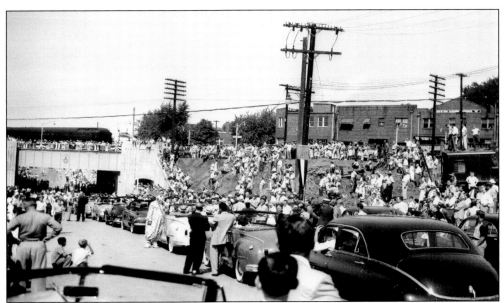

SOUTH SIDE OF THE GEORGIA AVENUE UNDERPASS, 1948. On September 11, 1948, the Silver Spring Avenue of Progress Celebration parade was held to mark the dedication of the $1.4-million ($11.6 million in 2005 dollars) Georgia Avenue underpass. An estimated 70,000 watched the 60-float parade along newly paved Georgia Avenue, a divided highway (U.S. Highway 29) with a median strip from East-West Highway to Colesville Road. The photograph is by Jay Braun. (JRH.)

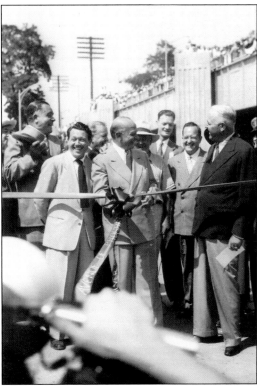

CUTTING THE "AVENUE OF PROGRESS" RIBBON. Pictured from left to right are Charles H. Kopeland (hands behind back), executive secretary of the Silver Spring Board of Trade and chairman of the Avenue of Progress committee; Maryland governor W. Preston Lane (behind the bow); Robert Sherwin (the tall man in the background), a member of the Silver Spring Avenue of Progress committee; Rudolf A. Lofstrand, member of the Maryland State Legislature; and B&O president R. B. White (holding paper). The photograph is by Jay Braun. (JRH.)

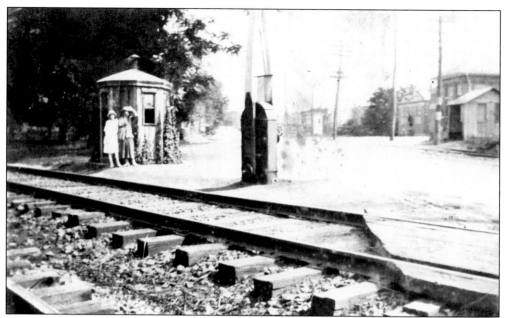

LOOKING NORTH ON GEORGIA AVENUE FROM RAILROAD CROSSING, C. 1917. Marion C. Schrider (left) and Trixie Wright pose in front of the watchman's booth. The watchman was responsible for lowering gates using a hand crank to halt traffic—pedestrian, vehicular, and streetcar—upon approach of a train. The wooden shed on the right is a streetcar waiting station. The dangerous crossing was eliminated in 1928 with the construction of an underpass. (CTS.)

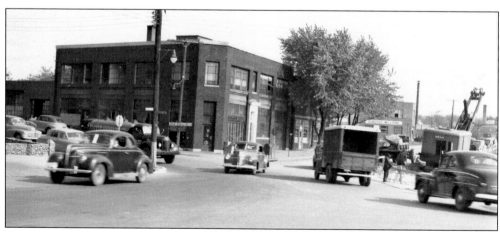

DETOUR AT GEORGIA AVENUE AND SLIGO AVENUE, 1947. Vehicles detour from southbound Georgia Avenue onto Philadelphia Avenue to go around construction of the Georgia Avenue underpass. Silver Spring's first newspaper, *The Maryland News* (1927–1973) was published and printed in the corner brick building, 8081 Georgia Avenue, from Memorial Day 1928 to c. 1953. Robert I. Black was the newspaper's first editor. (EBL.)

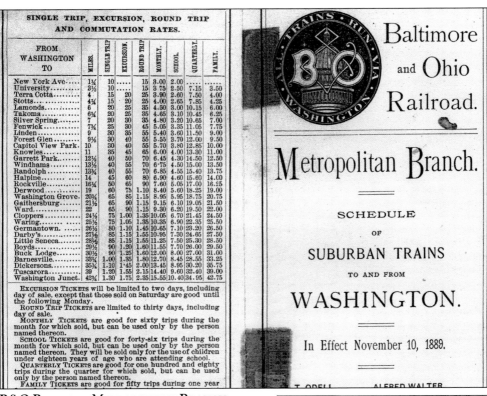

Baltimore and Ohio Railroad.

Metropolitan Branch.

SCHEDULE OF SUBURBAN TRAINS TO AND FROM

WASHINGTON.

In Effect November 10, 1889.

T. ODELL ALFRED WALTER

B&O Railroad Metropolitan Branch 1889 Schedule. B&O Railroad service came to Silver Spring in 1873. A single-trip ticket in 1889 from Silver Spring to Washington, D.C.'s Union Station cost 20¢ ($4.11 in 2005 dollars) and took from 17 to 25 minutes, with six stops in between. On Metro, which parallels the Metropolitan Branch, the same trip in 2005 costs $2.20 and takes about 14 minutes, with five stops in between. (DCPL.)

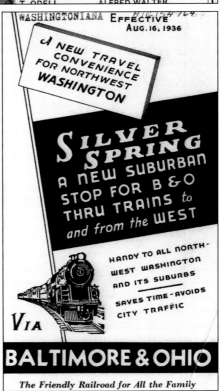

WASHINGTONIANA Effective Aug. 16, 1936

A NEW TRAVEL CONVENIENCE FOR NORTHWEST WASHINGTON

SILVER SPRING

A NEW SUBURBAN STOP FOR B & O THRU TRAINS to and from the WEST

HANDY TO ALL NORTHWEST WASHINGTON AND ITS SUBURBS

SAVES TIME - AVOIDS CITY TRAFFIC

VIA

BALTIMORE & OHIO

The Friendly Railroad for All the Family

"Silver Spring A New Suburban Stop for B & O Thru Train" Brochure Cover. On August 16, 1936, Silver Spring became a suburban stop for through trains to and from the West. No longer did passengers have to go all the way to Union Station in Washington, D.C., for western trips. Trains that stopped at Silver Spring included the *Capitol Limited*, *National Limited*, *Western States Limited*, *The Diplomat*, and *The Ambassador*. (DCPL.)

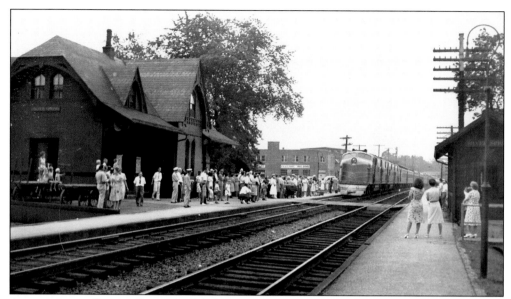

ARRIVING AT SILVER SPRING'S B&O RAILROAD STATION, 8100 GEORGIA AVENUE. A westbound train approaches Silver Spring's original 1878 Ruskinian Gothic-style passenger station designed by Baltimore architect Ephraim Francis Baldwin. The station was razed in August 1945 for construction of a new modern station. Baldwin's 1873 Rockville, Maryland, station, from which the Silver Spring station was patterned, still stands. This photograph was taken in 1941. (MCHS.)

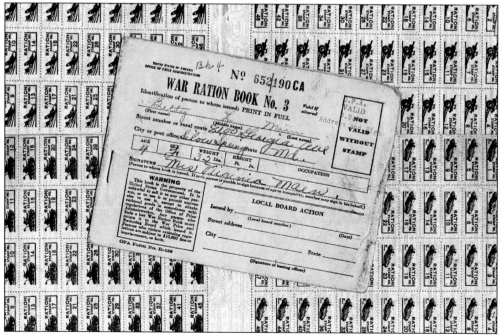

WAR RATION BOOK, 1943. This war ration book belonged to four-year-old Betty Louise Main, who lived with her parents and brothers on the top floor of the 1878 B&O Railroad station. Her father was Russell S. Main, who began working for the B&O in 1915 and served as the Silver Spring station agent from 1942 to 1964. (BMF.)

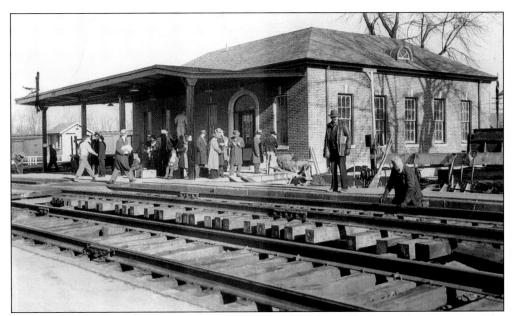

B&O Railroad Station Poised to Open. "New Silver Spring Station—Exterior view of the new $85,000 [$873,000 in 2005 dollars] Baltimore & Ohio Railroad station in Silver Spring. Although work on the structure, which will be about one-third larger than the old building, has not yet been completed, employees are scheduled to move in tonight." The photograph and text are from the *Evening Star*, December 11, 1946. (DCPL.)

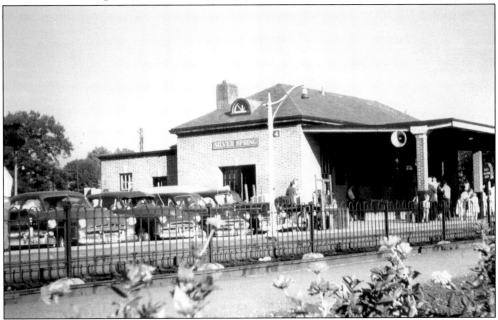

Track-Side View of the B&O Station, 1952. Station agent Robert B. Davis took this photo of the north end of the Colonial Revival–style station on a busy Saturday, September 6, 1952. Davis worked at the station from 1945 to 1987, working his way up from a part-time baggage handler to passenger agent. Note the "paper clip" fence between the tracks and eastbound platform. (RBD.)

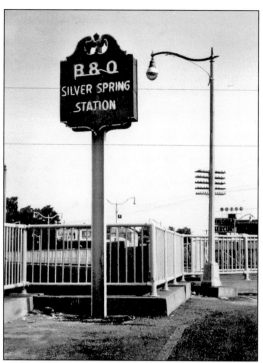

B&O Silver Spring Station Neon Sign. It is unknown when or why this 14-foot-tall neon sign that overlooked Georgia Avenue was removed. Designed in the Colonial Revival–style to compliment the station, it is hoped that this sign can be replicated in the near future. The photograph was taken on July 7, 1963. (TLU.)

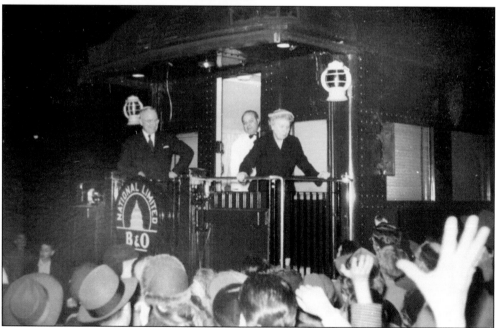

The Trumans Bid Farewell to Silver Spring, January 20, 1953. Pres. Harry S Truman and First Lady Bess Truman briefly stop at the Silver Spring B&O railroad station en route to Independence, Missouri. Earlier that day, outgoing-president Truman had attended the noon presidential inauguration of his successor Dwight. D. Eisenhower. "Ike" allowed the Trumans use of the presidential Pullman car, *Ferdinand Magellan*, to return home. Photo by Ara Mesrobian (AR.)

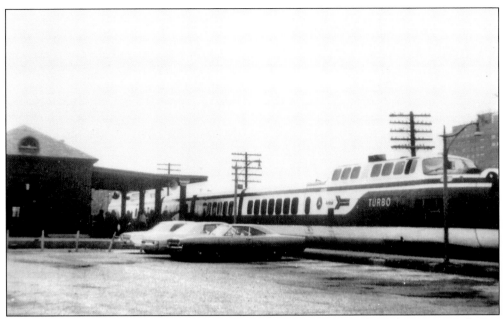

Amtrak Turbo Train Stops at Silver Spring, April 1972. Less than a year after its creation on May 1, 1971, Amtrak placed the Turbo Train into operation on February 7, 1972, between Washington, D.C., and Parkersburg, West Virginia. Designed to whisk passengers between metropolitan centers at 170 miles per hour, the route never lived up to Amtrak's expectations in terms of speed or passengers and was discontinued by year's end. (GS.)

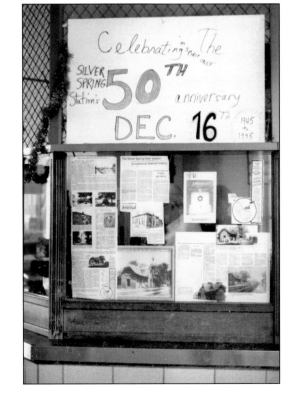

Silver Spring B&O Railroad Station 50th-Anniversary Display, 1995. MARC (Maryland Rail Commuter) passenger agent Mike Kelley put together this display commemorating the 50th anniversary of the opening of the Silver Spring station on December 16, 1945. The written "in spirit only" reflected station-owner CSX Transportation's lack of interest in celebrating the event. (JAM.)

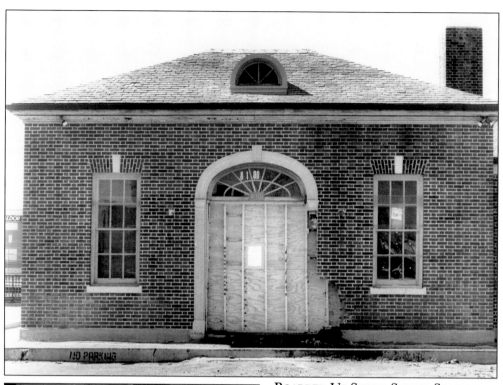

BOARDED-UP SILVER SPRING STATION.
On February 24, 1997, an automobile traveling south on Georgia Avenue crashed into the station after its steering and brakes failed. The following month, station owner CSX Transportation applied for a demolition permit, rallying Montgomery Preservation, Inc., the Silver Spring Historical Society (SSHS), and other historic preservationists to save and restore the station. (JAM.)

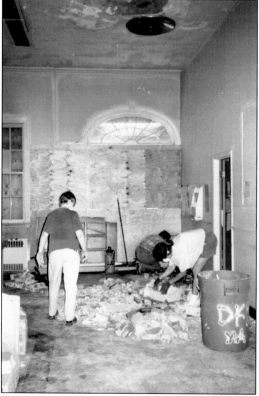

CLEANING UP THE RUBBLE, 1998.
On June 30, 1998, a ceremony was held in which Montgomery Preservation, Inc. (MPI), accepted ownership of the Silver Spring Railroad Station from CSX Transportation along with a $50,000 contribution toward building repair. That summer, members of MPI and SSHS began cleaning up in preparation for restoration work. (JAM.)

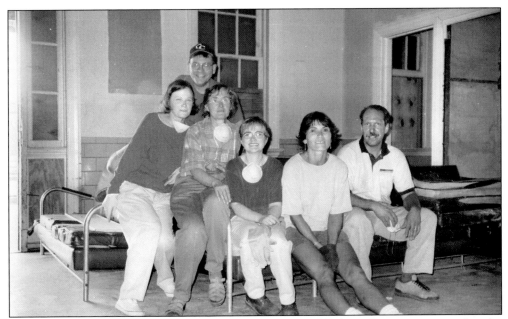

A Job Well Done, 1998. Members of the B&O Station Working Committee pose after the initial cleaning up of the Silver Spring station. Sitting on the station's original tubular steel benches in this photograph by Gene Slatick are, from left to right, Nancy Urban, Jerry A. McCoy, Marilyn Slatick, Carol Slatick, Maria Hoey, and Dean Brenneman. (JAM.)

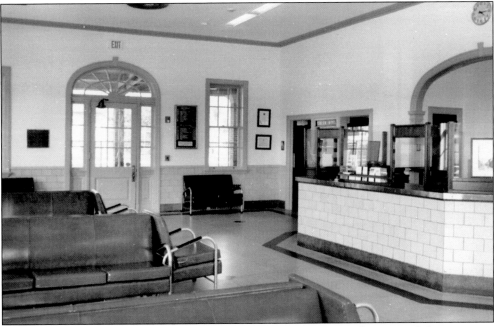

Restored Interior of Silver Spring B&O Station, 2005. This view of the passenger waiting room looks toward the track side of the station. Benches were reupholstered to match original colors and material. Paint colors on walls and trim reproduced original designs. Available for rent, the railroad station was placed on the National Register of Historic Places in 2000. For information, contact MPI at (301) 495-4915 or visit www.montgomerypreservation.org. (JAM.)

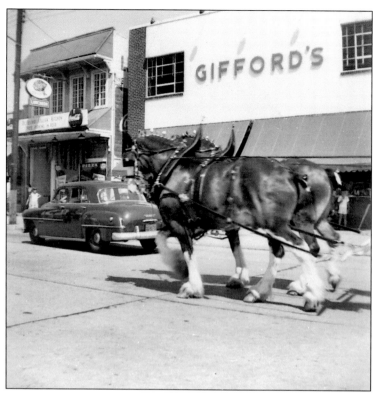

GIFFORD'S ICE CREAM, 8101 GEORGIA AVENUE. Gifford's opened in 1938 and closed in 1984. This 1956 photograph is the only known detailed image of the exterior that has surfaced; interior photographs remain to be discovered. The Budweiser Clydesdale horses were part of a team pulling the famous Anheuser-Busch beer wagon. Other photographs show the team has a front and rear motorcycle escort. (BMF.)

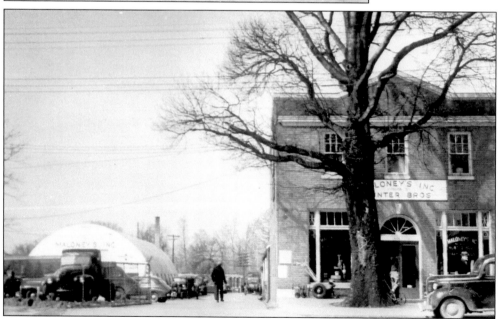

HUNTER BROTHERS HARDWARE, 8126 GEORGIA AVENUE. John H. and Thomas Hunter opened Hunter Brothers Hardware in 1912 on what John described as "the most lonesome spot" between Glenmont and the city of Washington. In 1945, John Hunter sold the business to Lawrence B. Maloney Sr. A year later, Maloney constructed a Quonset hut as part of his International Harvester regional headquarters. This photograph is c. 1946. (KM.)

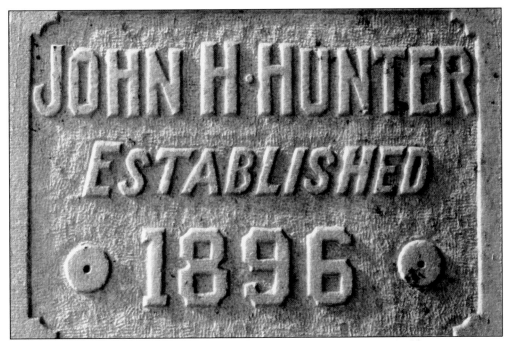

JOHN H. HUNTER CORNERSTONE. John H. Hunter was born in Lay Hill, Maryland, in 1879 and started his business career as a farm implement salesman in Washington, D.C. on June 1, 1896. He likely had this cornerstone made for installation in the façade of 8126 Georgia Avenue, which he built in 1925, to publicize his 29 years in the hardware business. Hunter died in 1960. This photograph was taken in 1999. (JAM.)

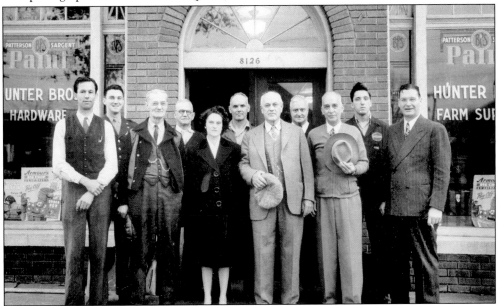

HUNTER BROTHERS HARDWARE EMPLOYEES. John H. Hunter stands near the center of the doorway holding his hat in this 1940s photograph. To his right is his daughter, Gertrude. At far right is Lawrence B. Mahoney Sr. The original 1925 front entrance, outlined by the door frame and lunette window, survives as an interior wall of the present structure. (KM.)

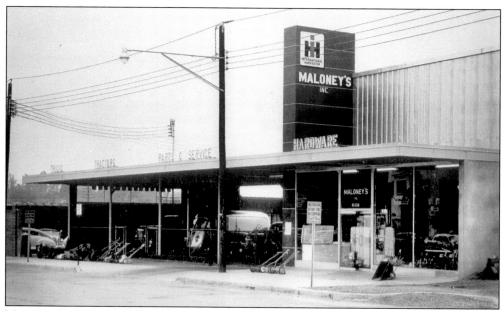

MALONEY'S, INC., 8126 GEORGIA AVENUE. In 1949, a "modernistic front," an all-glass display window, was added to the front elevation of the 1925 structure. Said Maloney, "Eye-appeal is buy appeal." This necessitated the removal of an estimated 175-year-old pin oak that sat between the storefront and Georgia Avenue—the tree had begun growing around the time of America's fight for independence from Great Britain. (KM.)

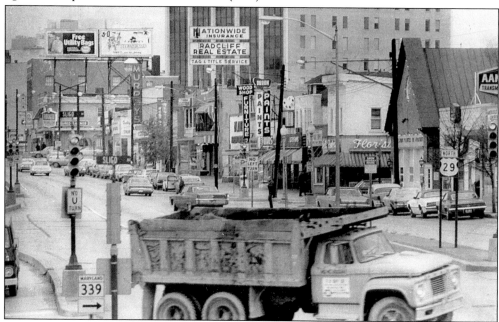

LOOKING NORTH ON GEORGIA AVENUE FROM SLIGO AVENUE, 1971. "Downtown Silver Spring—ripe for renewal, businessmen feel." The photograph by Joseph Silverman appeared in the *Evening Star* on February 1, 1971. The pair of outdoor advertising boards (left) offers an interesting study in contrasts: free utility (trash) bags from Esso and the "Adults Only" soft-core porn film, *The Stewardesses 3D*. (DCPL.)

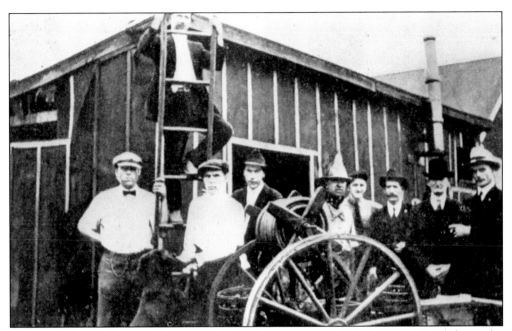

ORIGINAL SILVER SPRING VOLUNTEER FIRE DEPARTMENT, 1915. James H. Cissel donated a shed that was located in the alley behind the Silver Spring Armory at 8131 Georgia Avenue for use as the first fire station. Original members were, from left to right, Ernest Sayer, Fred L. Lutes (on ladder), George Hall, Clay V. Davis, Fred N. Oden (fire chief), Victor Bender, Edward Jones, William Glover, and William J. Jouvenal (president). (SSHS.)

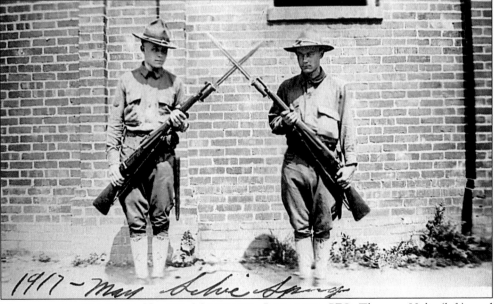

MEMBERS OF COMPANY K, 1ST MARYLAND INFANTRY. PFC Thomas Holt (left) and PFC John S. Elliott display crossed bayonet rifles on the Silver Spring Avenue side of the Silver Spring Armory in this May 1917 photograph. Company K's first tour of duty was in 1916 when sent to Eagle Pass, Texas, to quell disturbances created by Mexican revolutionary Francisco "Pancho" Villa. (SSHS.)

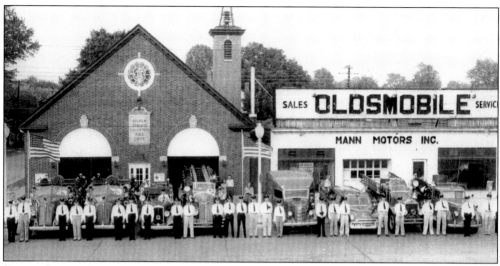

SILVER SPRING VOLUNTEER FIRE DEPARTMENT (SSVFD) NO. 1, 8131 GEORGIA AVENUE. The company and apparatus of No. 1 pose for photographer Ernest Gosbee in the early 1950s. Constructed as the Silver Spring Armory in 1914, the station's Colonial Revival façade replaced the Armory's original Gothic Revival one in 1932. Decorative architectural lunettes above the two engine bays were demolished between 1955 and 1956 to create three new doors. (GL.)

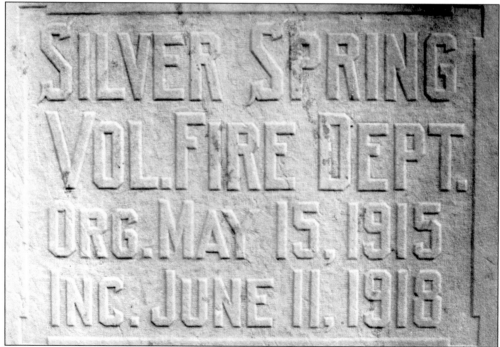

SSVFD NO. 1 CORNERSTONE. The SSVFD No. 1 was organized by the Ladies Cooperative Improvement Society 10 days after the Silver Spring Post Office burned down on May 5, 1915. On June 11, 1918, the company incorporated and purchased the former 1914 Silver Spring Armory from the State of Maryland for $5,500 ($79,400 in 2005 dollars). The building is listed on Montgomery County's Locational Atlas and Index of Historic Sites. This photograph was taken in 2000. (JAM.)

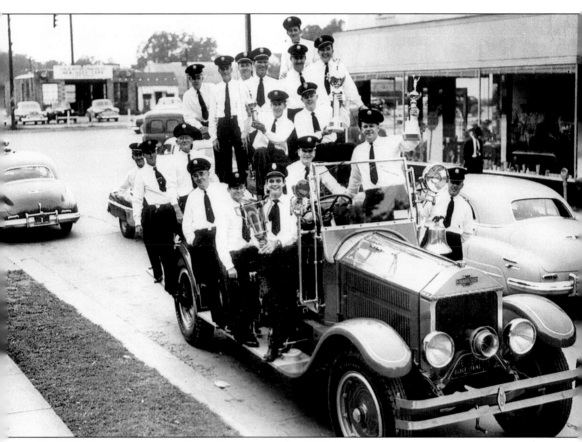

SSVFD No. 1 Trophy Cup Winners. The 1950 Montgomery County Association of Volunteer Firemen annual parade awarded No. 1 cups for the best-kept piece of apparatus more than 10 years old, best appearing company, and oldest pumper in actual service. Standing second on the running board behind the fireman holding the trophy is Ernie Brandt; behind him is Chris Kronenbitter, with his hand in his pocket (EPJ.)

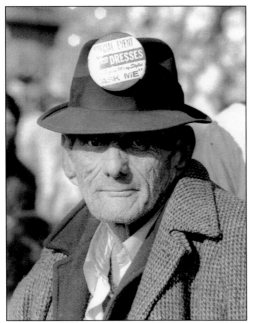
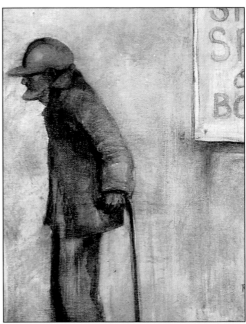

(Above, left) **NORMAN LANE, THE "MAYOR" OF SILVER SPRING.** Affectionately nicknamed the "Mayor," Norman Lane spent a good part of 25 years walking the streets and alleys of downtown Silver Spring. He died in 1987 at 76, his body found in the back of an abandoned taxicab parked in a lot off of Sligo Avenue. This photograph was taken by Dave Stovall in 1971. (DS.)

(Above, right) **OIL STUDY OF NORMAN LANE.** Fred Folsom makes paintings, drawings, and lithographs of Lane. This 1987 study depicts Lane, wearing one of his many hats, walking alongside the Silver Spring Auto Body Shop. Owner Bob Phillips let him to sleep there in exchange for doing small chores. The shop was located at 8225 Mayor Lane. (JAM.)

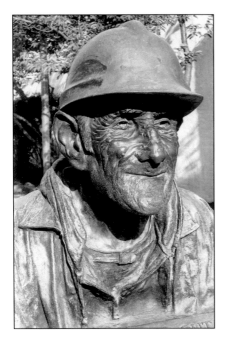

BRONZE PORTRAIT BUST OF NORMAN LANE. Located in *Mayor's Promenade*, a small, landscaped alley next to 8221 Georgia Avenue, this portrait bust by Fred Folsom was dedicated in 1991. "Mayor" Lane's catchphrase was "Don't worry about it." A plaque on the statue reads, "Remembering the loving kindhearted forbearance of the people of Silver Spring who cared for this homeless man for twenty five years." This photograph was taken in 2005. (JAM.)

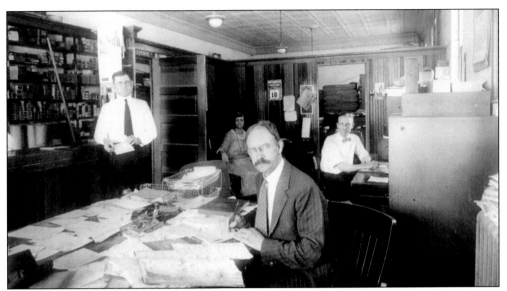

SILVER SPRING BUILDING SUPPLY COMPANY EMPLOYEES, 8222–8226 GEORGIA AVENUE AND 1004 RIPLEY STREET. James H. Cissel (center with mustache), president of the Silver Spring Building Supply Company, poses with his employees in this photo taken July 18, 1924. Cissel's sister sits in the corner. Cissel was and long-time president of the Silver Spring National Bank in 1910 and a founding member of the original Silver Spring Chamber of Commerce. (EBL.)

FRONT ELEVATION, 8222–8226 GEORGIA AVENUE. Constructed c. 1924, this two-story structure with slate canopy roof, seen here in 2004, remains in virtually original condition. Plans call for the structure to be restored to its original appearance by its present owner and named the James Herbert Cissel Building. E. Brooke Lee's North Washington Realty Company was located on the second floor concurrently with Cissel's company. (JAM.)

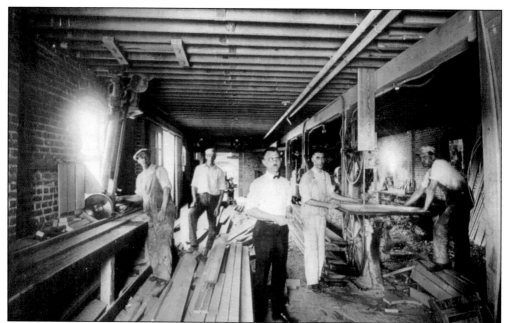

SILVER SPRING BUILDING SUPPLY COMPANY MILLWORKS, 1924. Manager Joseph E. Griffin stands in the center of the millworks located to the rear of 8222–8226 Georgia Avenue on the opposite side of Ripley Street (then named Poplar Avenue). A B&O Railroad siding extended half the length of Ripley, ending just west of the millworks. This allowed for ease in delivery of lumber and other supplies. (EBL.)

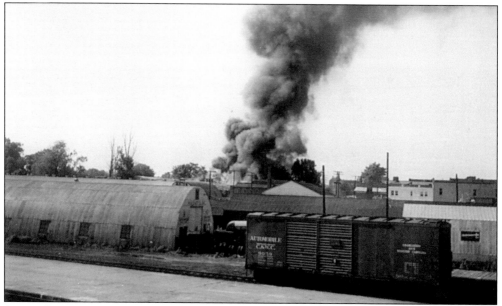

SILVER SPRING BUILDING SUPPLY COMPANY FIRE, JULY 4, 1949. A black plume of smoke rises from the largest fire in Silver Spring's history, which injured 50 firemen and caused $400,000 in damages ($3 million in 2005 dollars). Discovered at 5:28 p.m., the blaze was under control in two hours but destroyed the Silver Spring Building Supply Company lumberyard and six of its buildings. The cause was arson. The photograph was taken by Robert B. Davis. (RBD.)

SILVER SPRING HOME BAKERY, 8223 GEORGIA AVENUE. Richard J. "Pop" Dietle and family are pictured in front of his newly opened bakery in 1926. With him, from left to right, are his sons Erwin, Richard, Herbert, and Henry. On the right is his wife, Matilda. The other woman is unidentified. The shop closed in 1936, but a bakery that he had opened in 1930 in Montgomery Hills became Dietle's Tavern in 1934. It closed in 2003. (JPH.)

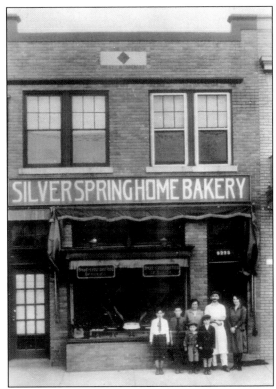

HARRY F. DUNCAN, LITTLE TAVERN SHOPS, INC., FOUNDER. Duncan (1899–1992) founded the Little Tavern Shops in Louisville, Kentucky, in 1927. In 1928, he relocated to Washington, D.C., and in 1940, he established his corporate headquarters at 1007 Ripley Street. Duncan poses with a model of his flagship restaurant, Silver Spring Little Tavern No. 1, established at 8230 Georgia Avenue c. 1935. Wellner Streets took the photograph for the *Star-News*, December 11, 1972. (DCPL.)

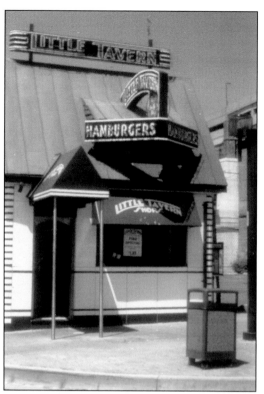

LITTLE TAVERN, 8230 GEORGIA AVENUE. The Little Tavern closed in 1991, and in 2003, its last owner listed it on eBay for $89,000. When no buyers surfaced, an offer was made to give it away, but the cost was prohibitive, as it had to be moved off site. The owners opposed historic designation and prevailed. The structure was razed in 2003 for new construction. The site remains vacant. Judy Reardon took this photograph in 1987. (SSHS.)

ORIGINAL LITTLE TAVERN SIGN. After Little Tavern closed in 1991, another hamburger chain named Ollie's operated out of 8230 Georgia Avenue until 1999. The original Little Tavern neon sign was removed and stored in a fenced-in area at the rear of the restaurant. One day it disappeared, reputedly hauled away to a landfill. This photograph was taken in 1996. (JAM.)

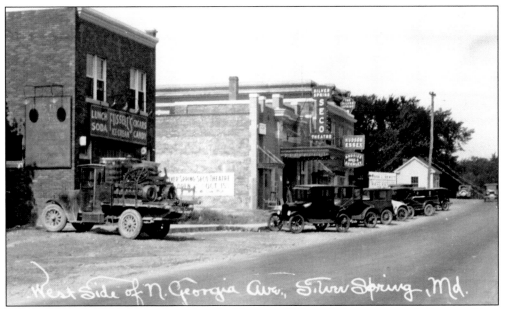

"West Side of N. Georgia Ave." This *c.* 1927 real-photo postcard depicts Silver Spring's first commercial and entertainment center, anchored by the SECO Theatre (8242–8244 Georgia Avenue). Developed by James H. Cissel, the series of buildings were designed by local architects Frank Baker Proctor and John M. Faulconer, also an engineer. The SECO opened on November 7, 1927, with the silent film *Fireman, Save my Child*, starring Wallace Beery. (JAM.)

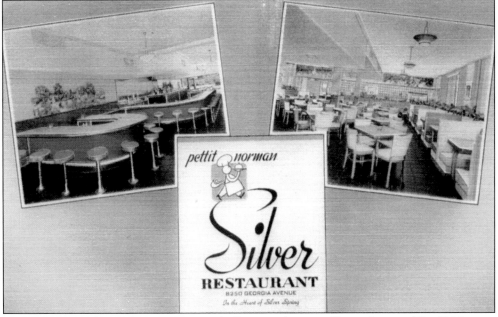

Pettit Norman Silver Restaurant, 8250 Georgia Avenue. Harvey Pettit and Ova D. Norman opened the Silver Restaurant in the Silver Building in 1946. Contemporary recollections indicate that the restaurant featured murals depicting Silver Spring history (three murals can be seen in this 1940s postcard view), but no detailed photographic documentation of them has surfaced. Damaged by a fire, the structure was razed *c.* 1972. The site remains vacant. (JJV.)

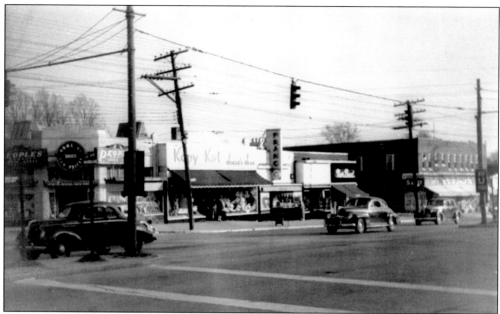

WEST SIDE 8300 BLOCK OF GEORGIA AVENUE, 1947. This was the block to shop in downtown Silver Spring for clothing and shoes. Located between Thayer Avenue and Bonifant Street were, from left to right, People's Drug Store, Kopy Kat Women's Wear, Franc (or Pranc) Shoes, Triplex Shoes, and NorBud Hosiery and Ready to Wear Shop. Katherine Bartley took this photograph. (SSHS.)

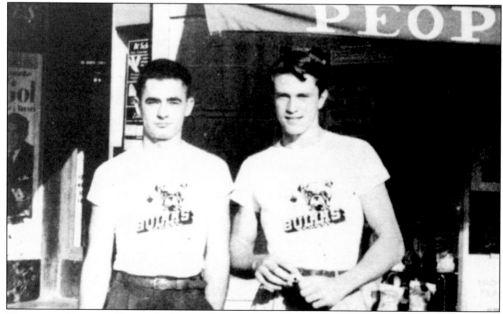

HANGING OUT AT PEOPLE'S DRUG STORE, 8315 GEORGIA AVENUE. This photograph of unidentified Bullis School students appeared in the school's 1952 yearbook, *Roll Call.* Bullis School, founded in 1930 by Comdr. William F. Bullis, was originally a preparatory school for the United States Naval Academy. It was located at the intersection of Houston and Cedar Streets in Silver Spring Park (East Silver Spring) from 1934 to 1963. (BS.)

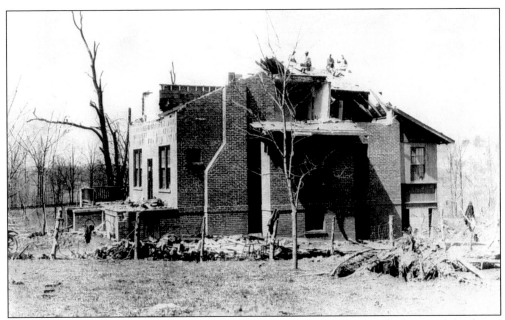

Tornado Hits Downtown Silver Spring. On April 5, 1923, a tornado destroyed this home at 1109 Oak Avenue (present Bonifant Street), one block west of Georgia Avenue. The home was occupied by John C. Cowell, a bricklayer, and William M. Cowell, a carpenter. The roof was blown off, as was the home's west elevation facing the B&O Railroad tracks (visible as a dark line in background to left of house). (SL.)

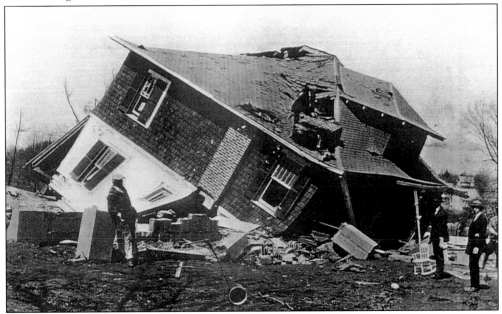

Dr. Frederick E. Dudley Jr. Home Destroyed. On April 5, 1923, nurse Leena Warren was giving a bath to two-and-a-half year old Margie Dudley at 8404 Maple Avenue (present Dixon Avenue) when the house tilted forward, and Margie slid through an opening onto the street, uninjured. The Dudleys had only moved in three weeks earlier. Four people were injured, five houses were destroyed, and a dozen others were damaged. (HDS.)

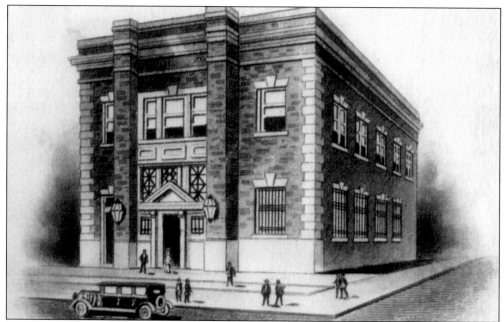

SILVER SPRING NATIONAL BANK, 8252 GEORGIA AVENUE. Relocated from its original location on the southeast corner of Georgia and Sligo Avenues, the Silver Spring National Bank reopened on September 1, 1925. Designed and built by architects Frank B. Proctor and John M. Faulconer, also an engineer, the bank contributed to the development of the west side of Georgia Avenue. This architectural rendering from the bank's letterhead is dated 1934. (EBL.)

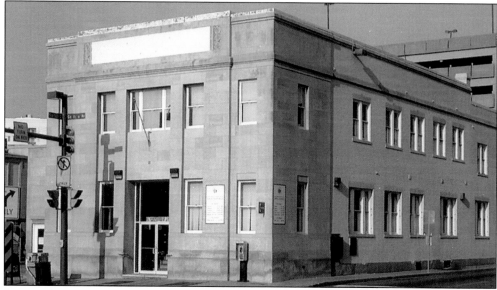

SUBURBAN NATIONAL BANK COMPANY, 8252 GEORGIA AVENUE. In 1938, the bank completed extensive alterations, having hired noted architectural and construction firm Tilghman Moyer Company of Allentown, Pennsylvania, to construct a new, 16-foot-deep Classical Revival limestone facade. Besides a new enlarged lobby, there were 11 tellers' wickets, new officers' rooms, and an enlarged vault. In 1951, the bank was enlarged again and renamed Suburban Trust Company. This photograph was taken in 2005. (JAM.)

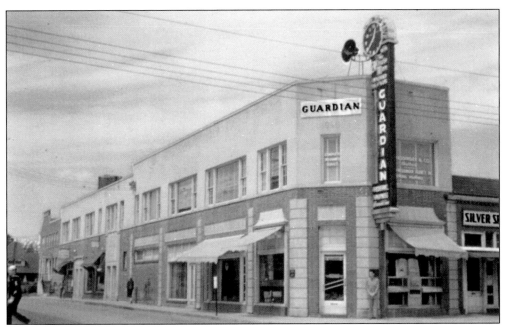

GUARDIAN BUILDING, 8400 GEORGIA AVENUE. On December 6, 1933, a crowd of 1,500 descended on the Silver Spring Liquor Dispensary to purchase the first legal liquor sold in Montgomery County since 1880. In 1946, a second story was added when the building became Guardian Federal Savings Association. This 1950s postcard was photographed by R. F. Body. The structure was razed in the 1980s. (JAM.)

"HELLO SILVER SPRIRK," 8411 GEORGIA AVENUE. This 1995 advertisement added a new twist to the frequent misspellings of Silver Spring that features an extra "s" at the end of "Spring." In 2004, the Montgomery County government and Clear Channel Outdoor, owner of billboards located throughout the county, ended a 30-year battle to remove them. This billboard will be removed by May 2006. (JAM.)

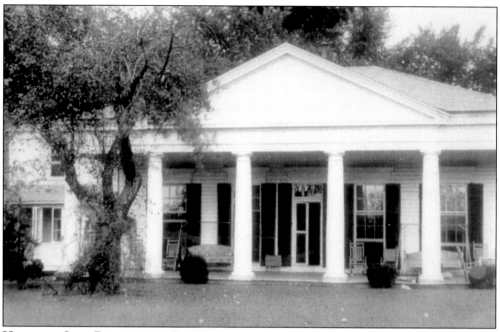

HOME OF GIST BLAIR, 8400 BLOCK GEORGIA AVENUE. Gist Blair (1860–1940), son of Montgomery Blair, constructed The Elms *c.* 1897 and lived there while serving as Silver Spring's first postmaster from 1899 to 1906. The second postmaster, Frank L. Hewitt, who served from 1906 to 1914, lived in the home, seen here around 1910, with his family from *c.* 1921 to *c.* 1927. The structure was razed *c.* 1932 for construction of the Silver Spring Post Office. (JPH.)

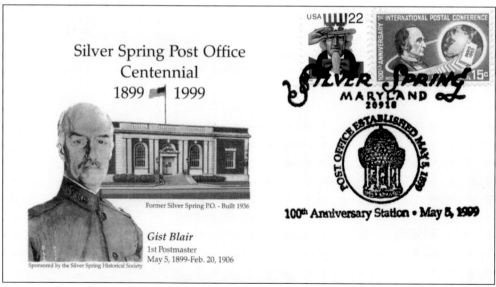

SILVER SPRING POST OFFICE CENTENNIAL COMMEMORATIVE ENVELOPE. Commemorating the establishment of the post office on May 5, 1899, the cachet features a World War I–era portrait of Blair and the 1936 Silver Spring Post Office. The 15¢ airmail stamp, first issued in Silver Spring on May 3, 1963, commemorated the 100th anniversary of the International Postal Conference. Montgomery Blair, depicted on the stamp, organized the conference. (SSHS.)

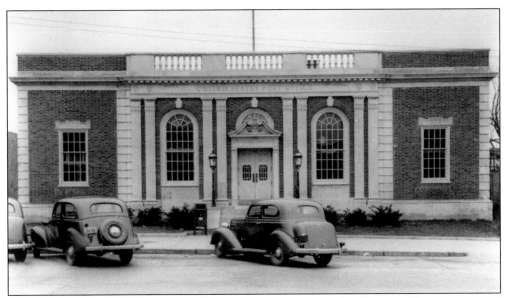

SILVER SPRING POST OFFICE, 8412 GEORGIA AVENUE. One of 1,100 post offices constructed in the United States between 1934 and 1944 that featured lobby murals or sculptures, the Silver Spring Post Office opened on March 1, 1937 and is pictured shortly after opening. A 1936 cornerstone is located at ground level to the left of the entrance. Louis A. Simon was the supervising architect of the Colonial Revival–style post office. (NA.)

DETAIL OF THE SILVER SPRING POST OFFICE'S MAIN ENTRANCE LINTEL. Edward Dunlap designed the ornate "Silver Spring Maryland" engraving over the post office's main entrance lintel in 1936. The engraving was reproduced as part of the May 5, 1999, philatelic pictorial cancellation applied to envelopes commemorating the 100th anniversary of the establishment of the Silver Spring Post Office (page 92). It is also used in the logo of the Silver Spring Historical Society (SSHS). This photograph was taken in 1999. (JAM.)

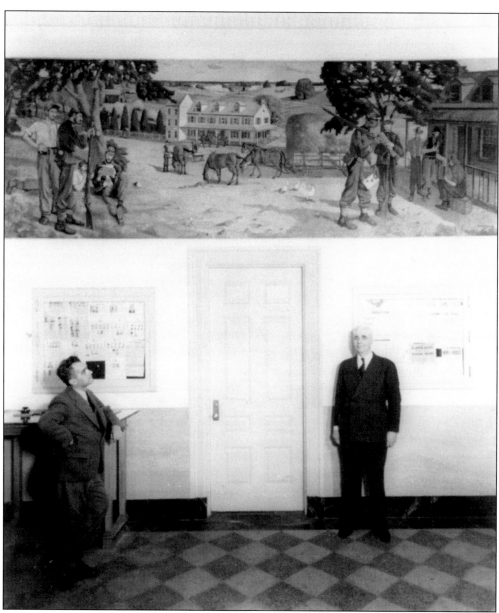

Posing with "The Old Tavern" Post Office Mural. Nicolai Cikovsky (left) admires his 16-foot-long mural commissioned by the Treasury Department Section of Painting and Sculpture for the Silver Spring Post Office in 1937. With him is Silver Spring postmaster Howard Griffith. The painting depicts the crossroads of Sligo, Maryland, at the end of the Civil War (the present intersection of Georgia Avenue and Colesville Road). The Rockville and Bethesda, Maryland, post offices also featured murals in their lobbies, in addition to 14 other Maryland post offices featuring artwork. In 1981, the Silver Spring Post Office closed, and the mural was removed, placed in storage, and forgotten. In 1994, Jerry A. McCoy began a three-year effort to raise awareness of the mural's importance. The Friends of the Silver Spring Library and other community groups raised $25,000 to conserve the mural. On July 7, 1997, the mural was unveiled in the Silver Spring Library at 8901 Colesville Road. (NA.)

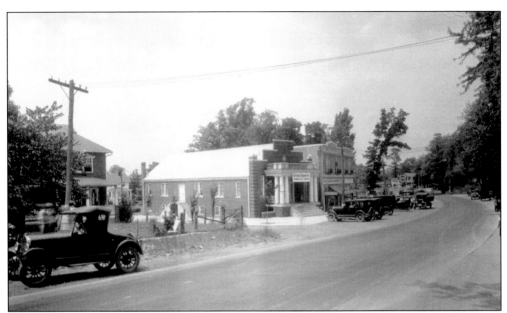

West Side of Georgia Avenue at Wayne Avenue, 1928. A private residence at 8424 Georgia Avenue occupies a corner lot at left. Across Wayne Avenue (then Harden Street) at right is the Knights of Columbus Hall, dedicated April 10, 1927. The banner on the portico reads, "Chicken Dinner Here Saturday Next 5 to 8 PM." Next to the hall is the Albert Buehler Provision Company. The photograph is by National Photo. (JPH.)

Warner E. Pumphrey Funeral Home Telephone Directory Listing, 1940. In 1932, the residence at 8424 Georgia Avenue was converted to use as a funeral home. Six years later, the house was razed and a new building constructed for the Warner E. Pumphrey Funeral Home. This structure was razed in the early 1980s for construction of 8484 Georgia Avenue. Shown is the funeral home's listing in the Chesapeake and Potomac Telephone Company of Baltimore City's 1940 directory. (MD.)

WARNER E. PUMPHREY

Distinctive Funeral Service

Lady Assistants CREMATIONS

ESTABLISHED 1854

8424 GEORGIA AVE. SILVER SPRING, MD.

SHepherd 5000

TO THE WAR VETERAN'S FAMILY
Funeral Services Without Forfeiting Any
Veteran's Allowance

AMBULANCE SERVICE

ROCKVILLE HOME Rockville 83

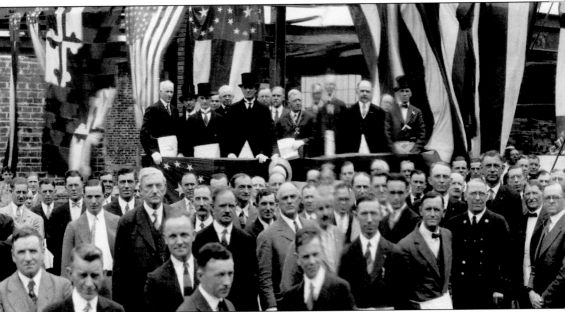

CORNERSTONE CEREMONY AT MASONIC TEMPLE, JUNE 18, 1927. Shown is a portion of a panoramic photo taken by Rideout of Washington, D.C., during the cornerstone laying ceremony at the Silver Spring Lodge No. 215, A.F.&A.M. of Maryland (Ancient, Free and Accepted Mason), 8435 Georgia Avenue. Placed within the cornerstone, made of Georgia granite, was a

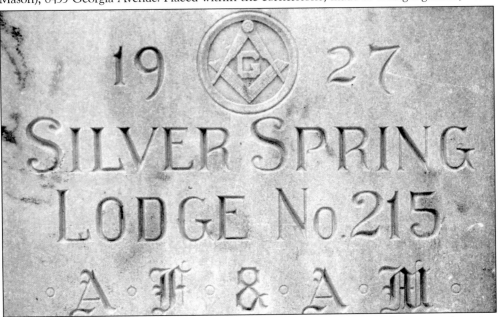

MASONIC TEMPLE CORNERSTONE. In 1998, the owner of 8435 Georgia Avenue undertook a façade renovation that included covering up the cornerstone. A plea from SSHS to preserve the visibility of the cornerstone as the historic "signature" of the building went unheeded. It remains buried under applied granite cladding. The Freemasonry symbol consists of a carpenter's square and compass, which represents the interaction between mind and matter. This photograph was taken in 1998. (JAM.)

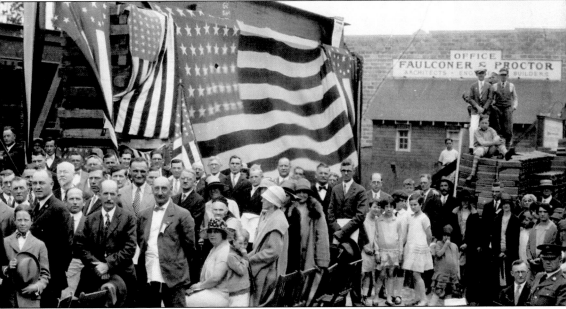

1927 silver dollar, a Bible, United States and Maryland flags, the roster of the Lodge membership, a copy of the *Takoma News*, and a copy of the *Evening Star*. The top of the cornerstone is visible to the right of the dignitaries standing on stage. Master of the Lodge Joseph A. Griffith opened the proceedings, and a group sang *America* and *The Star Spangled Banner*. (SPG.)

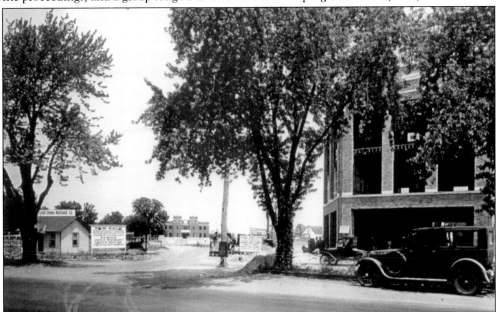

LOOKING EAST ON MONTGOMERY (WAYNE) AVENUE FROM GEORGIA AVENUE, C. 1928. The nearly completed Masonic Temple (right) stands across the street from the Silver Spring Mortgage Company. The sign reads, "For Sale Business and Residential Lots on this Tract Beautiful Homes and Bungalows in this Section North Woodside, Silver Spring and Blair Farms John D. Springer Louis A Yost, Sr. Loans on Montgomery County Properties." Photograph by National Photo. (JPH.)

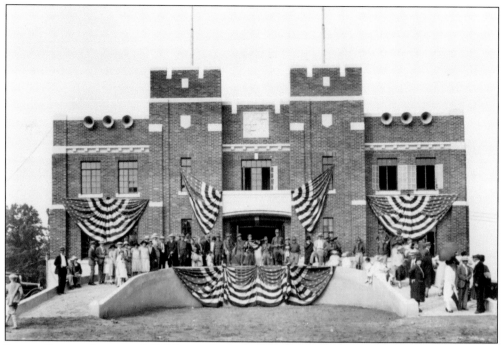

SILVER SPRING ARMORY, 945 WAYNE AVENUE. The home of the Maryland National Guard's 29th "Blue and Gray" Infantry Division, which served in World Wars I and II, the structure's castellated façade was typical of early-20th-century armory architecture. The Silver Spring Armory opened on August 20, 1927, and for the next 71 years served as Silver Spring's de facto town hall and community center. Malcolm Walter took this photograph on opening day. (PR.)

SUMMER DANCE PROGRAM AT THE ARMORY, 1998. Actively utilized until forced to close its doors on September 20, 1998, the armory was razed less than two months later. A victim of the "Downtown Silver Spring" redevelopment project, approval to demolish the historic landmark, listed on Montgomery County's Master Plan for Historic Preservation, was granted by the Montgomery County Historic Preservation Commission by a vote of four to three. (JAM.)

VACANT ARMORY SITE, 1998. From 1998 to 2003, the site of the armory, bordered by Wayne Avenue on the right, Pershing Drive on the left, and Fenton Street in the distant rear, remained vacant. Another structure endangered as of 2005 is the First Baptist Church of Silver Spring (distant right) at 8415 Fenton Street. Dedicated on March 8, 1957, the church was designed by Ronald S. Senseman. (JAM.)

WAYNE AVENUE PARKING GARAGE, 2005. On May 7, 2004, a seven-story, 1,789-space parking garage was opened on the former site of the Silver Spring Armory. The armory's dated 1927 cornerstone, main entrance lintel, and cast-concrete Maryland flag are displayed in front of the garage. The top half of the Maryland flag is placed on the support base installed at one end of garage, and the bottom half is at the opposite end. (JAM.)

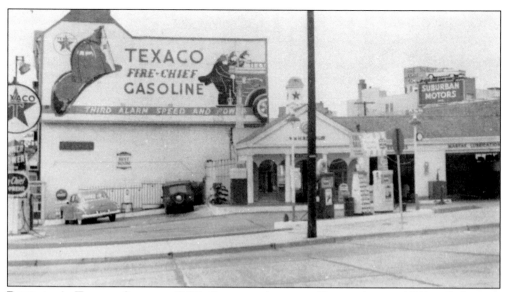

BOBINGER'S TEXACO SERVICE, 8501 GEORGIA AVENUE. Operated since 1952 as Bobinger's Texaco, this gas station had been in operation since the 1930s. Contemporary recollections indicate that the Texaco Fire-Chief Gasoline mural ("Third Alarm Speed and Power"), painted on the side of an apartment building that faced Georgia Avenue, had applied neon tubing that flashed in sequence, making it appear as if the fire engine was moving. (SSHS.)

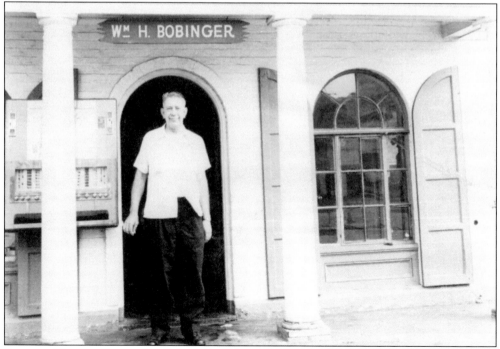

SERVICE WITH A SMILE. Lt. Col. William H. Bobinger (U.S. Army, retired) purchased the Texaco station in 1952 and operated it until the mid-1980s when his wife, Agnes (Tillie), took over daily operations. Upon the death of both in 1985, their daughter, Vickie Bobinger Millett, operated the station until it closed on October 30, 1998, a victim of redevelopment. (SSHS.)

EDDIE M. WARNER (1906–1996), ORIGINAL OWNER OF TASTEE DINERS. "From his desk in the Bethesda, MD, Tastee Diner, Eddie Warner transacts the paper work incidental to running his four diners." Warner owned diners in Silver Spring, Rockville, and Bethesda, Maryland, and Fairfax, Virginia. Warner's desk has been restored by the SSHS. The picture and quote are from *The Diner: Monthly Publication of the Restaurant World*, October, 1947. (RJSG.)

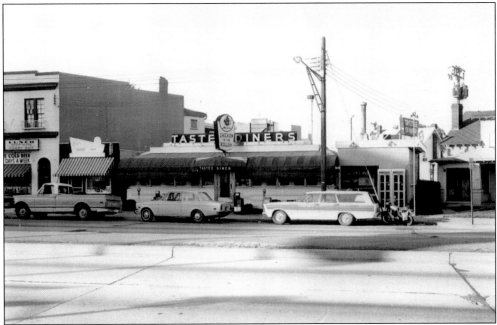

TASTEE DINER, 8516 GEORGIA AVENUE. Tastee Diner is a classic example of commercial Art Deco/Moderne machine-age architecture. Prefabricated in 1946 by Jerry O'Mahoney, Inc., of Elizabeth, New Jersey, the diner was designated a Montgomery County historic landmark in 1994. The buildings to the left of Tastee Diner were razed in the mid-1970s to widen Wayne Avenue. This early-1970s photo is by Executive Photo Service. (ER.)

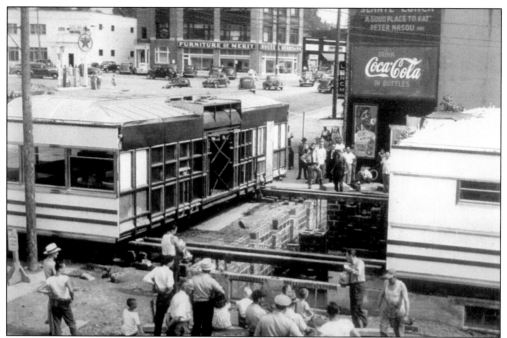

ASSEMBLING THE TASTEE DINER. Tastee Diner was delivered in two sections during the summer of 1946 and positioned over an excavated basement and prepared foundation. Opened on August 28, 1946, Warner's 40th birthday, Tastee Diner replaced an earlier diner that had opened on the site in 1934 named Meadow's Dining Car. Warner had the Meadow's moved to 321 East Montgomery Avenue in Rockville, where it opened in June 1946. (RJSG.)

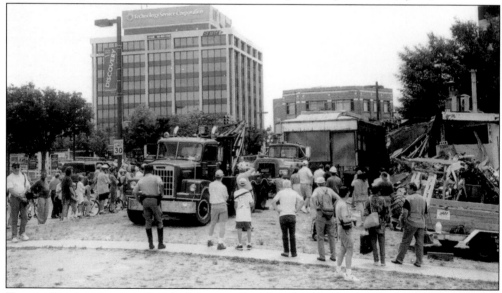

TASTEE DINER MOVING ON. A large crowd gathered under sunny skies on June 17, 2000, to watch Tastee Diner transported to its new home. Serenaded by a Dixieland band and tap dancers, the separation of the front dining car from the rear kitchen proceeded smoothly until the two halves became stuck just as they were about to clear one another. Eight hours later, Tastee Diner continued on its journey up Georgia Avenue. (JAM.)

EUNICE WILLIAMS, TASTEE DINER WAITRESS, 1955.
Eunice Williams (Ramsey) poses in front of the Tastee Diner. In 2005, Eunice marked her 50th anniversary of working at Tastee Diner. The diner, and Eunice, relocated in 2000 to make way for construction of the world headquarters of Discovery Communication, Inc. (ER.)

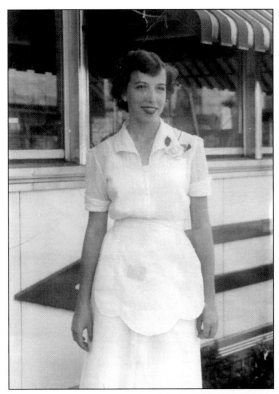

OPEN FOR BUSINESS. Approximately six weeks after Tastee Diner closed its door on Georgia Avenue for the final time, a new era began on July 24, 2000, at 8601 Cameron Street. Featuring larger dining rooms, outside seating, and a revamped menu, the $2-million renovation included a recreation of the original rooftop "Tastee Diners" neon sign (but changing "diners" from plural to singular). This photograph was taken in 2000. (JAM.)

"ZIPPY THE PINHEAD." Tastee Diner's relocation received national publicity when its move was featured in the syndicated comic strip *Zippy the Pinhead* on October 2, 2000. Zippy artist and creator Bill Griffith explained, "the diner is a place where people are kind of open with each other . . . where you can sit down and start a fairly intimate or existential conversation with the guy sitting next to you at the counter." The Silver Spring Tastee Diner is one of only four pre-1950 diners remaining in operation in Maryland. This original drawing is in the collection of the SSHS. (SSHS.)

MONTGOMERY COUNTY BUILDING, 8528 GEORGIA AVENUE. Published in 1946 by Curt Teich and Company, Inc., of Chicago, this postcard depicts the Montgomery County Building. Constructed in 1927, the structure housed a Montgomery County police substation that remained in use until 1961, when it was relocated to the Montgomery County Suburban Office Building at 801 Sligo Avenue. Pvt. Guy L. Jones was the first officer assigned to patrol Silver Spring in 1922. (JAM.)

DOWNTOWN SILVER SPRING'S FIRST BICYCLE RACE. On July 17, 2005, the first annual Martens Volvo Silver Spring Grand Prix was held. Over 200 experienced racers competed in five events. Here riders in the Men's 40+ category race through the intersection of Georgia and Wayne Avenues. Buildings in the background are, from left to right, Discovery Communications (built 2003), Lee Plaza (built 1987), and American Nurses Association (built 2004). (JAM.)

"STARTING WEST." From left to right, Silver Spring residents Joseph C. Cissel (age 21), James E. Roeder (age 21), Marcel Zimmerman (age unknown), and George A. Hood (age 26) pose in June 1920 on Georgia Avenue in front of a Model T Ford. Silver Spring resident John S. Elliott, who was 20 years old when he took this picture, assembled a c. 1917–1920 photo album from which this image was obtained. All were members of Company K, 115th Infantry. (SSHS.)

ACME SUPER MARKET, SOUTHEAST CORNER OF GEORGIA AND ELLSWORTH AVENUE. Monroe Ford participated in the Silver Spring Avenue of Progress Celebration parade marking the completion of the Georgia Avenue underpass. Jay Braun took this photograph on September 11, 1948. (JRH.)

LOOKING NORTH ON GEORGIA AVENUE. Excavation work has begun (center right) at the intersection of Georgia Avenue and Colesville Road for construction on architect John Eberson's Silver Theatre and Shopping Center. Already underway is the Gulf service station (to right of sign) that will occupy the shopping center's novel parking lot. Note the backs of residences that face Colesville Road. The photograph was taken around 1937 or 1938. (BWF.)

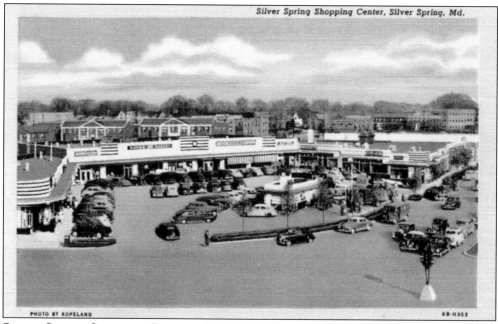

SILVER SPRING SHOPPING CENTER, 8533–8575 GEORGIA AVENUE. Published in 1946 by Curt Teich and Company, Inc., of Chicago, this postcard depicts architect John Eberson's 1938 Silver Spring Shopping Center. Based upon a photograph taken by Charles Kopeland, executive secretary of the Silver Spring Board of Trade, it depicts the shopping center's busy parking lot, one of the earliest constructed in the Washington metropolitan area to accompany commercial frontage. (JAM.)

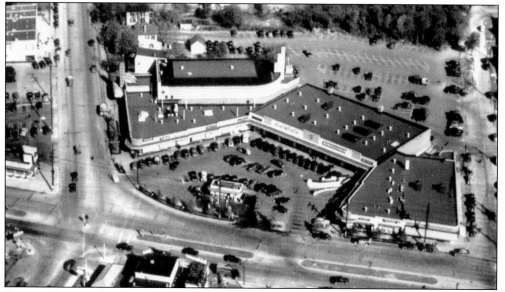

AERIAL VIEW OF GEORGIA AVENUE AND COLESVILLE ROAD, 1941. Ample parking surrounds the Silver Spring Shopping Center and Silver Theatre, which opened on October 27, 1938. Visible in the right corner of the parking lot facing Georgia Avenue is the entrance to an underground ramp (white flared shape) that allowed vehicles to pass under the shopping center to travel from one lot to the other. (EBL.)

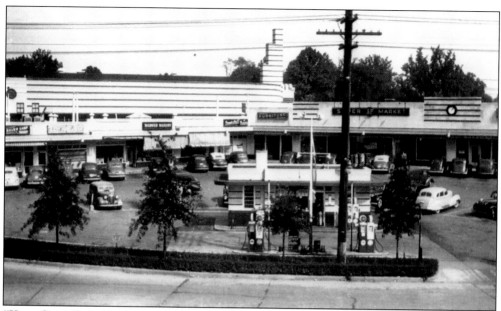

"YOU CAN BUY EVERYTHING FROM TOOTHPICKS TO RADIOS." The October 27, 1938, *Washington Post* featured a special section profiling the Silver Spring Shopping Center. Of the 19 "modern" stores available, some of them included, from left to right in this *c.* 1941 photograph, the Silver Shop, Lee's Tea Garden, Ethel's Millinery and Bags, Barker Bakery, Irene's Ladies Apparel and Accessory Shop, Peggy's Hall of Beauty, George's Furniture Exchange, and Atlantic and Pacific Tea Company. (SSHS.)

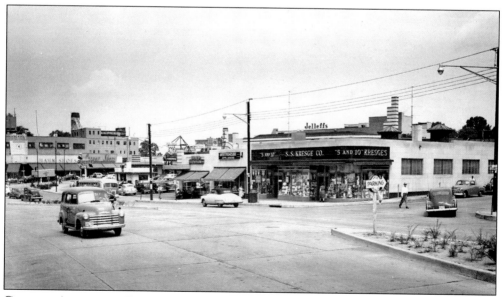

GEORGIA AVENUE AT ELLSWORTH DRIVE, 1950. This photo appeared in the article, "Silver Spring Solves Parking and Business Problems By Making It Easy for a Motorist to Stop and Buy" in the *Washington Star Pictorial Magazine*, September 24, 1950. In 1946, E. Brooke Lee spearheaded a plan for the county government to create off-street parking to lure customers to Silver Spring's business section. The article's photographs were by John Horan and Gene Abbott. (DCPL.)

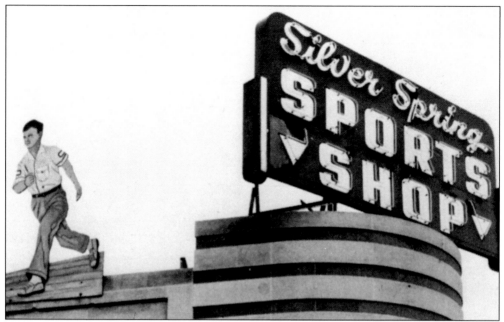

SILVER SPRING SPORTS SHOP, 8535–8539 (NOW 8525) GEORGIA AVENUE. Located near the south end of the Silver Spring Shopping Center from 1961 to c. 1965 was the Silver Spring Sports Shop, managed by Jack Fagles. This advertisement is from Northwood High School's 1961 yearbook, *The Arrowhead.* (PA.)

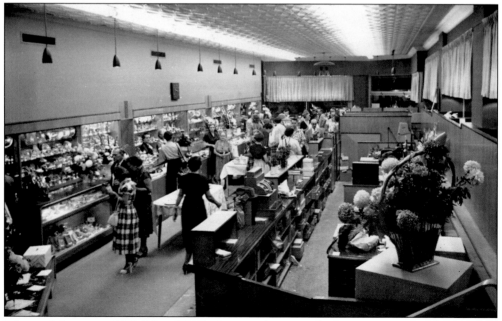

WRIGHT'S JEWELRY, 8575 (NOW 8541) GEORGIA AVENUE. At the opposite end of the shopping center in this c. 1955 photograph, fronting Colesville Road, was William M. Wright's third jewelry store, opened in 1955. The store's motto was "Wright on the Corner." His first shop opened at 8421 Georgia Avenue in 1936. From the 1940s to early 1950s, Wright operated out of 8229 Georgia Avenue. (BWF.)

ENVELOPE MAILED TO (ILLEGIBLE) FIELDS. This envelope was mailed on May 27, 1884, from the Sligo, Maryland, post office, which sporadically served the community at the crossroads of the Washington and Brookeville Turnpike (Georgia Avenue) and the Ashton, Colesville, and Sligo Turnpike (Colesville Road) from *c.* 1835 to 1907. Matthew Fields first published the *Montgomery Sentinel* in 1855. It is the oldest newspaper still published in Montgomery County. (JAM.)

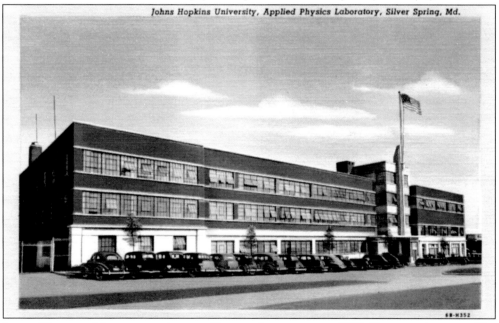

JOHNS HOPKINS UNIVERSITY APPLIED PHYSICS LABORATORY, 8621 GEORGIA AVENUE. The "APL" took over Wolf Motor Co. in 1942, and by 1944, this structure was completed. Here was developed the Proximity VT (Variable Time) Fuse, credited by military leaders as second in importance to the atomic bomb among World War II weapons. The laboratory closed in 1976, and the building was razed in the 1980s. This postcard was published in 1946 by Curt Teich and Company. (JAM.)

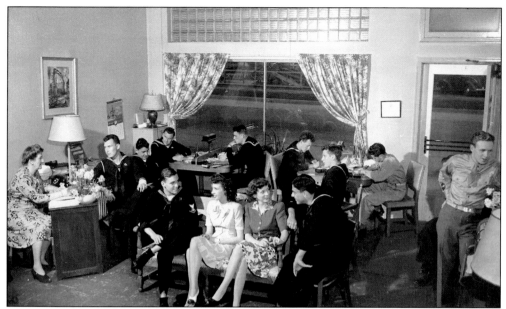

UNITED SERVICE ORGANIZATION (USO) LOUNGE, 8644 GEORGIA AVENUE. The USO lounge opened on August 30, 1943, and closed in 1945 after World War II ended. The lounge's director was Mrs. John C. Keele (left), president of the Women's Improvement Club of Silver Spring from 1936 to 1937. The USO's mission remains to provide morale, welfare and recreation-type services to men and women in uniform. Del Ankers took this photograph in 1944. (BWF.)

BANK OF SILVER SPRING, 8701 (NOW 8665) GEORGIA AVENUE. Established in 1946, the Bank of Silver Spring was the community's third financial institution. In 1949, it opened a new $300,000 building ($2.3 million in 2005 dollars). Note the bank's logo, the Acorn Gazebo, featured in its neon sign. This inspirational message attesting to the importance of a business training background appeared in the Montgomery Blair High School 1957 yearbook, *Silverlogue*. (SSHS.)

WEST SIDE OF GEORGIA AVENUE AT CAMERON STREET. Giant Food sits across Cameron Street from Jay Braun's bungalow home. In 1954, the Perpetual Building Association wanted to construct its bank (now 8700 Georgia) on the site of the home, seen here in the 1950s. Braun, not wanting to sell, was eventually offered $67,000 ($463,000 in 2005 dollars), the highest amount per square foot that a residential property had sold for in Maryland. (JRH.)

GRACE EPISCOPAL CHURCH, 9100 BLOCK OF GEORGIA AVENUE. Published in 1946 by Curt Teich and Company, Inc., of Chicago, this postcard depicts the second church, completed in 1897 and used until 1956, when it was razed and replaced with the present edifice at 1607 Grace Church Road. An 1896 monument to 17 unknown Confederate soldiers killed in the Battle of Fort Stevens, July 11–12, 1864, is located in the church's cemetery. (JAM.)

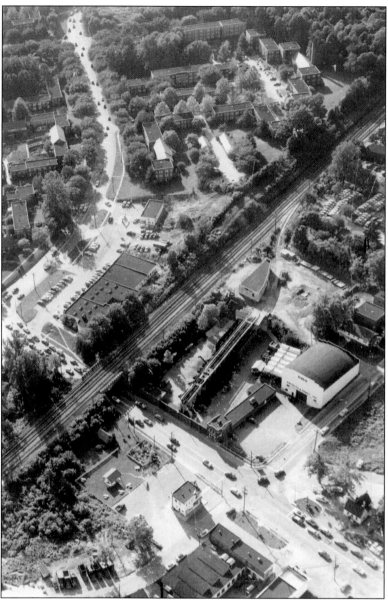

AERIAL VIEW OF COLESVILLE ROAD AT RAILROAD TRACKS, 1955. Near the bottom center, Reindeer Frozen Custard stands at the corner of Colesville Road and Second Avenue. Reindeer featured ample parking and its own grassy picnic area. Across Colesville Road is Griffith and Perry, Inc., a coal, fuel, and oil company. An elevated railroad siding branched off the B&O Railroad so coal and other supplies could be delivered. At top left is East-West Highway, separating two sections of the Falkland Apartments. The section at left was constructed in 1936 and the right section in 1938. Designed by Louis Justement, Falkland was the first rental housing project in Montgomery County whose mortgage was guaranteed by the federal government (through the Federal Housing Administration). First Lady Eleanor Roosevelt cut the ribbon on opening day. The SSHS has nominated the apartment complex to the National Register of Historic Places. The nomination is pending. The picture is a detail of an *Evening Star* photograph whose publication date is unknown. (DCPL.)

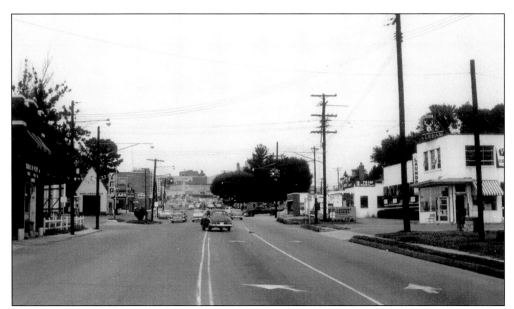

COLESVILLE ROAD LOOKING EAST TOWARD GEORGIA AVENUE, 1950S. Reindeer Frozen Custard (right) relocated next to the B&O Railroad tracks from its original location at 8651 Colesville Road when Sam Eig purchased the property in 1949. Reindeer permanently closed in 1972 when the Washington Metropolitan Area Transit Authority purchased the property for construction of the Silver Spring Metro Station (opened in 1978). (EBL.)

JUDGE CECIL M. ROEDER (1898–1989). Judge Roeder, a Silver Spring resident and Montgomery County Orphans Court judge from 1962 to 1966, sits in the back of a Stanley Steamer parked on the Colesville Road side of Ray E. Barrett Esso. Judge Roeder authored the children's book *Oscar, the Redheaded Mouse* (1978), the story of a mouse and his adventures in Silver Spring. This photograph was taken in 1962. (CFM.)

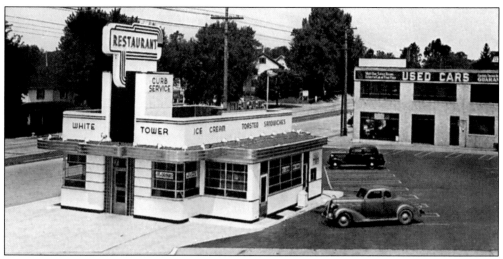

WHITE TOWER, 8600 COLESVILLE ROAD, 1938. Thomas E. Saxe of Milwaukee, Wisconsin, founded the White Tower hamburger chain in 1926. Silver Spring #1 was constructed in 1938 and featured a streamlined, cantilevered, neon-illuminated "Restaurant" sign that announced its prominent location on the northeast corner of Colesville Road and Georgia Avenue. The restaurant featured sodas, full-course meals, and sundaes. Photo from *White Towers* by Paul Hirshorn and Steven Izenour (1979). (MIT.)

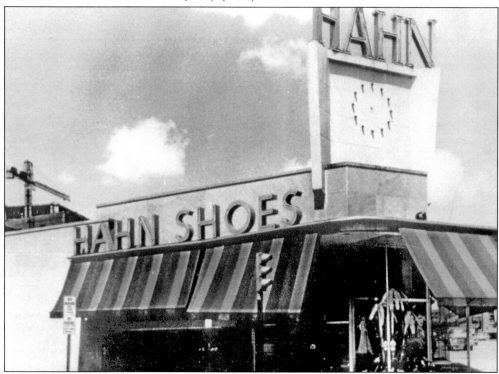

HAHN SHOES, 8601 GEORGIA AVENUE. In the fall of 1949, Hahn Shoes opened a store on the former site of White Tower, which had been jacked up and moved to the east end of the White Tower parking lot facing Colesville Road. By the early 1980s, this structure was razed to make way for Lee Plaza, which opened in 1986 with the same address. (SSHS.)

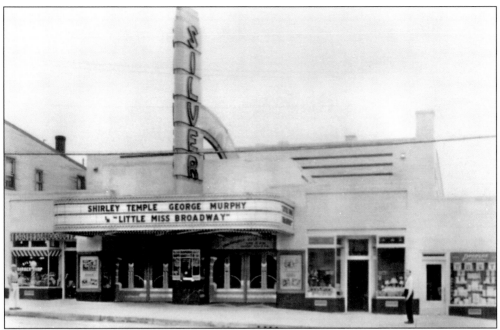

SILVER THEATRE, 8633 COLESVILLE ROAD, 1938. Designed by John Eberson, who also designed the Silver Spring Shopping Center, the Silver opened on September 14, 1938, with the Warner Brothers film *Four Daughters*, starring John Garfield and the Lane Sisters. Two days later, when this photo was taken, the film *Little Miss Broadway* was playing. The last film shown, in October 1984, was *Woman in Red*, starring Gene Wilder. (MWJC.)

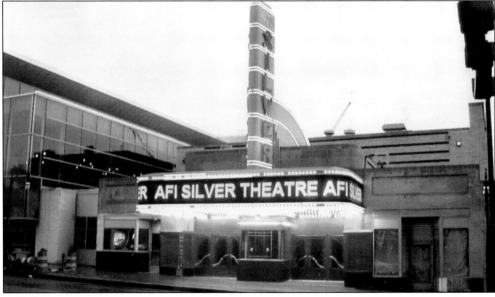

AFI SILVER THEATRE, 2003. On February 1, 1994, the Art Deco Society of Washington succeeded in placing the theatre and shopping center complex on Montgomery County's Master Plan for Historic Preservation. On April 4, 2003, the theatre reopened as the East Coast home of the American Film Institute. Screened that evening was the 1943 film *The Ox-Bow Incident*, attended by actor Clint Eastwood. This photograph was taken on March 30, 2003. (JAM.)

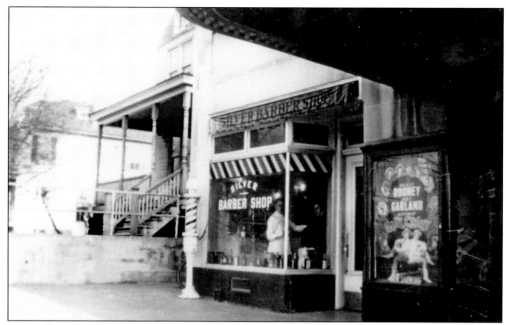

SILVER BARBER SHOP, 1944. The Silver Barber Shop opened adjacent to the Silver Theatre in 1938. Brothers Preston and Bennett Riley Jr. began working there the following year and became well known for their haircutting expertise. In the mid-1950s, Bennett relocated the Silver Barber Shop to 951 Ellsworth Drive. The shop's curving rear wall has been preserved as an interior wall of present 933 Ellsworth Drive. (RB.)

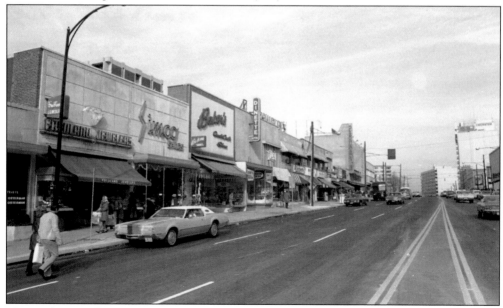

NORTH SIDE OF COLESVILLE ROAD LOOKING EAST FROM GEORGIA AVENUE, 1971. From left to right, the Colesville Road businesses (with addresses) are Osterman Optometrists (8614), Fredland Jewelers (8616), Simco Shoes (8618), Baker's Shoes (8622), Dinette Center (8624), Palacio Women's Clothes (8626), and Shirley's Women's Clothes (8630). The photograph was taken by Dave Stovall. (DJ.)

(Above, left) **THELMA B. PEASE (1909–1993), REINDEER FROZEN CUSTARD MANAGER, 1940.** Thelma and her twin sister, Vera B. Emery, were co-owners of the Reindeer Frozen Custard stand at 8651 Colesville Road. (RBP.)

(Above, right) **REINDEER FROZEN CUSTARD, 8651 COLESVILLE ROAD, 1940.** The first Reindeer Frozen Custard opened in 1936 in Washington, D.C., at 847 Bladensburg Road NE. The Silver Spring location opened in 1940 and relocated in 1949 to 8430 Colesville Road. This location closed in 1972. Other stores were located in Arlington, Virginia, and Baltimore County. (RBP.)

ARTHUR PEASE SR. (1906–1999). Thelma's husband was Arthur, who, with the occasional help of their three sons, Arthur Jr., Robert, and Ronald, helped her run Reindeer Frozen Custard. All had a short commute, as the Pease family lived in a house that sat directly behind the stand. This photograph was taken in 1940. (RBP.)

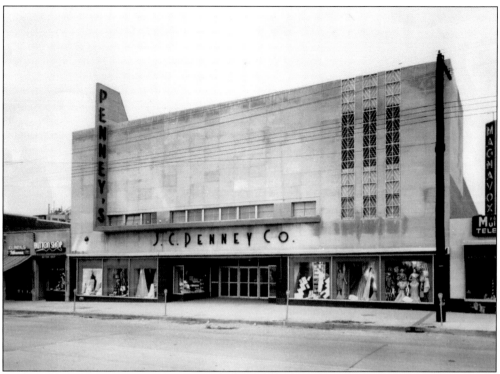

J. C. PENNEY COMPANY, 8664 COLESVILLE ROAD, 1950. Silver Spring store No. 1334 opened on August 17, 1950, under the management of Lincoln E. Martin. In 1956, the store was remodeled, and the selling area increased from 20,014 to 38,097 square feet. The address was also changed to 8656 Colesville Road. (JCP.)

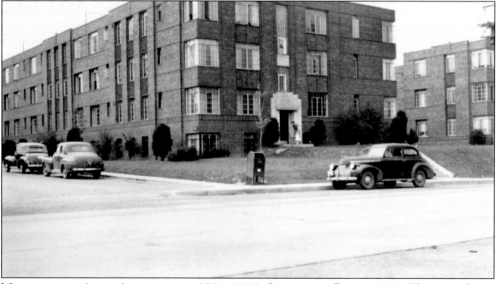

MONTGOMERY ARMS APARTMENTS, 8700–8722 COLESVILLE ROAD, 1947. These art deco–style garden apartments were designed by George T. Santmyers in 1941. Listed on Montgomery County's Master Plan for Historic Preservation, the apartments symbolize the development of downtown Silver Spring as a major suburban center in which to live, work, and shop. (EBL.)

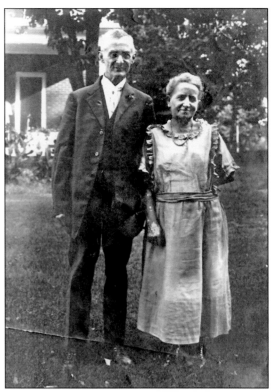

CHARLES H. (1865–1928) AND ESTHER A. ROEDER (1866–1954) AT 8727 COLESVILLE ROAD. The Roeders pose in the front yard of their home, built in 1922. Charles worked at the Government Printing Office in Washington, D.C., and Esther was a schoolteacher. They married in 1889. Roeder Road is named after them. (CFM.)

COLESVILLE ROAD LOOKING TOWARD ROEDER HOME, 1925. Prior to 1940, the Roeder home had an address of 8634 Colesville Road. The view is looking toward Silver Spring from the Holland home, site of the present Silver Spring Library. To the left of the house is a small pump house, and behind that is the double garage. By the early 1950s, the block that the Roeder home occupied had been rezoned as commercial property. (CFM.)

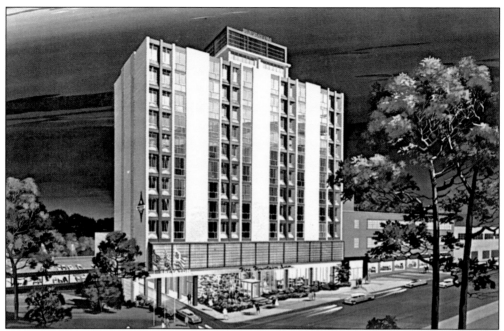

SHERATON-SILVER SPRING MOTOR INN, 8727 COLESVILLE ROAD. In 1962, construction began on the (originally named) Fire Fountain Inn, an 11-story, 162-room hotel constructed on the site of the Roeder home. Architect Fon J. Montgomery incorporated an outside fountain that featured "bursting bubbles of gas and sprays of water." The $2.25-million hotel ($14 million in 2005 dollars) opened in 1963 under the Sheraton name. This postcard is *c.* 1963. (JAM.)

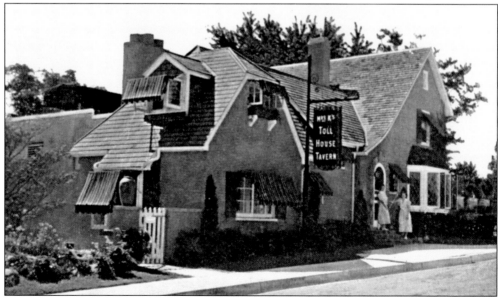

MRS. K'S TOLL HOUSE, 9201 COLESVILLE ROAD. Mrs. K's is the oldest continuously operating restaurant in Silver Spring. Harvey and Blanche (Mrs. K.) Kreuzburg opened the restaurant on April 1, 1930. The structure began as Sligo Tollgate No. 1 on the Ashton, Colesville, and Sligo Turnpike (today's Colesville Road), which ceased operation *c.* 1913. The message on this 1930s postcard reads "had a wonderful dinner and saw a marvelous collection of antiques." (JAM.)

Four

EAST SILVER SPRING'S FORGOTTEN ORIGIN
Silver Spring Park

In 1905, surveyor Charles J. Maddox was commissioned by developer R. Holt Easley to plat a new subdivision named Silver Spring Park. The borders of this development were Bonifant Street on the north, present-day Cedar Street on the east, Thayer Avenue on the south, and the Washington and Brookeville Turnpike (Georgia Avenue) on the west. This subdivision was part of a 106-acre parcel that Easley purchased in 1902 from Julia M. Thayer, widow of wealthy Washington, D.C., merchant William Thayer.

By 1907, Easley was advertising lots for sale in his new subdivision in both the *Washington Post* and the *Evening Star*. Business was probably slow in the beginning with not much development in Silver Spring, but by c. 1915, Silver Spring experienced its first building boom, and the demand for lots started to increase. A large advertisement in the April 14, 1917, *Evening Star* announced, "Come out today and select a choice lot at Silver Spring Park. The most beautiful suburb of Washington. Lots 2 1/2 cents to 10 cents a square foot [42¢ to $1.70 in 2005 dollars]." The sales pitch continued. "If you want to live in the ideal neighborhood—with all environments high class—move out to Silver Spring Park. High altitude, insuring pure air and good health; surrounded by homes of the wealthiest people of Washington. Fine spring water. Excellent car service. Property advancing in value every day. Come out today before prices are beyond your reach, and double your money in the next year."

Over the decades, the original subdivision name became consumed by the expanding and all-encompassing moniker "East Silver Spring." Extending in a northeast direction from the east side of Silver Spring's Central Business District all the way to the Capital Beltway and the Montgomery–Prince George's County border, the present name of this century-old neighborhood fails to acknowledge its historic origins. Perhaps this can be rectified. The following photographs of this "ideal neighborhood" represent but a small sample of the rich documentation that remains to be mined.

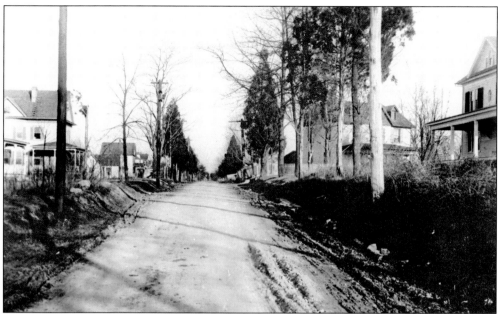

SLIGO AVENUE'S 900 BLOCK, LOOKING EAST FROM GEORGIA AVENUE, C. 1910. Originally named Blair Road, Sligo Avenue is the oldest road in Silver Spring Park, connecting the Washington and Brookeville Turnpike (Georgia Avenue) to Bladensburg Road (University Boulevard/Route 193). It was also called Bluestone Road for its crushed stone paving. The partially visible porch on left was the home of James H. Cissel. Samuel D. Water's house, on the right, burned in 1913. (MCHS.)

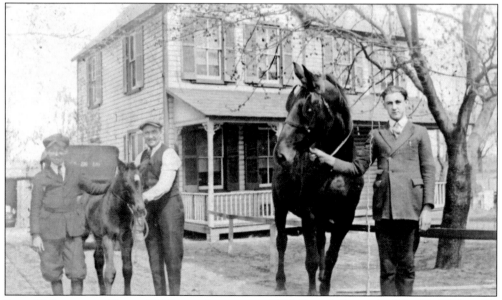

JOHN T. SCHRIDER HOME, 607 SLIGO AVENUE, C. 1920. From left to right, John D., William E., and Charles T. Schrider Sr. pose in front of the family home, built in 1897. The family's grocery business, John T. Schrider and Son, was located next door at 609 Sligo Avenue. The intersection of Sligo Avenue and Schrider Street marks the vicinity where the family home and business was located. (CTS.)

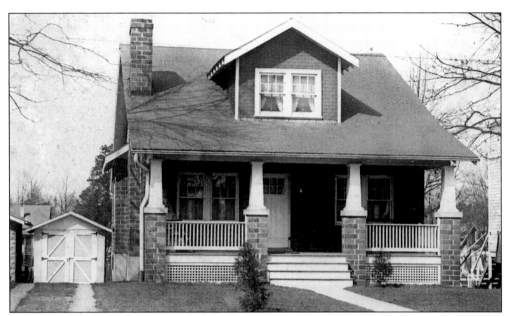

JOHN T. CRAWFORD HOME, 805 SILVER SPRING AVENUE, C. 1920. John T. Crawford and his wife, Estelle, first appear in the 1918 *Nelson's Washington Suburban Directory* at this address. John was listed as a signal operator and in subsequent directories as an electrician. The home, designed by architect John M. Faulconer (who lived on Thayer Avenue), remains virtually unchanged on the exterior. (MAG.)

BUNGALOWS AT 914 AND 916 THAYER AVENUE, 2005. These bungalows are rare survivors of the residential neighborhood that once occupied the 900 block of Thayer, Silver Spring, and Sligo avenues during the first half of the 20th century. Both homes were constructed *c.* 1922. The 1927–1928 *Polk's Washington Suburban Directory* lists Louis C. Kengla, a meat cutter, as residing at 916. Presently occupied by businesses, future preservation of these bungalows is uncertain. (JAM.)

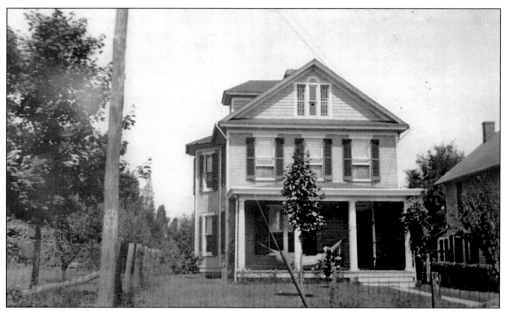

915 Thayer Avenue, c. 1915. Fred L. Lutes (1889–1966) and his family lived in this home from 1915 to 1951. Lutes was one of the pioneers of modern Silver Spring, helping to establish the Silver Spring Volunteer Fire Department. He joined the Silver Spring National Bank in 1923, eventually becoming its president when it became Suburban Trust in 1951. The family home was sold in 1965 and razed shortly after. (SL.)

The Lutes Family, Summer of 1915. Sitting on the front steps of their home at 915 Thayer Avenue are, from left to right, Fred L. Lutes, Lawrence V. Lutes II, Mildred Lutes (Biggs), and Louise Carolyn Forni Lutes. (SL.)

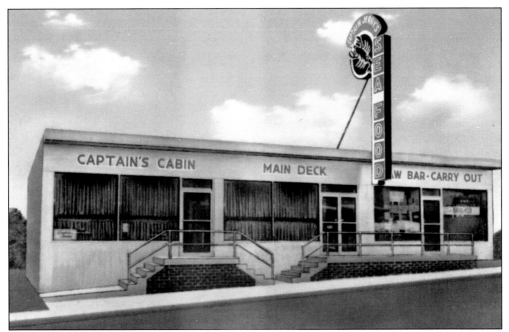

CAPTAIN JERRY'S SEA FOOD RESTAURANT, 908 (NOW 902) THAYER AVENUE, 1960S. Captain Jerry was Jerry Kalivas. His "The Capt's Own Athenian Recipe," using either red snapper, rock bass, or sea bass chunks, was rubber stamped onto the back of this 1960s postcard. The restaurant closed in 1968 with the passing of the Captain. Contact the Silver Spring Historical Society (SSHS) for the full recipe! (JJV.)

902 THAYER AVENUE, 1919. William B. Neuman lived here until his death in 1921. His son, Alan B., and daughter-in-law, Margaret, then occupied the home. In 1923, John and Nora Wrenn were residents, after whom the moniker "Wrenn's Nest" was given the house. Roy M. Heiser owned the house in the background, to which a storefront was constructed during World War II that housed Captain White's Oyster House, later becoming Captain Jerry's. (RKN.)

800 THAYER AVENUE, 1940S. Constructed in 1921, the earliest documented residents of this house were Bryan (a police officer) and Elva Torrance. Excess stone, left over from the construction of the 1892–1899 Washington, D.C., Post Office at Twelfth and Pennsylvania Avenue NW, was used in the 1940s for construction of the home's porch columns and (not shown) extant corner retaining wall. The bungalow was featured as the cover story in the March 27, 1986, "Washington Home" section of the *Washington Post*. (SN.)

"SLVRSPG" MARYLAND LICENSE PLATE. Proud of where he lives, the author expresses similar pride in the board members of the Silver Spring Historical Society for all of their hard work expended over the years to preserve Silver Spring's rich history. To George French, Marilyn Slatick, Gene Slatick, Carol Slatick, Marcie Stickle, Mary Reardon, and the late Judy Reardon—THANK YOU!